Modern Scribes and Lettering Artists

Modern Scribes and Lettering Artists

PROPERTY OF CUYAHOGA COUNTY PUBLIC LIBRARY

A Studio Vista book published by Cassell Ltd 35 Red Lion Square, London wcir 4sG and at Sydney, Auckland, Toronto, Johannesburg, an affiliate of Macmillan Publishing Co. Inc. New York

Copyright © Studio Vista First published in 1980

All rights reserved. No part of this publication may be reproduced, stored in any retrieval system, or transmitted in any form or by any means, electronic, mechanical, photocopying, recording or otherwise, without the prior permission in writing of the Publishers.

ISBN 0 289 70921 0

Filmset and printed by BAS Printers Limited, Over Wallop, Hampshire

> Q745.61 M72

Acknowledgements 6
Introduction 7
Calligraphy and lettering 9
Calligraphy and lettering for reproduction 87
Inscriptional lettering 127
Index of calligraphers 157
Calligraphy societies 159

Calligraphy services 160

Acknowledgements

The publishers wish to thank in particular The Society of Scribes & Illuminators, London for all their patient work and enthusiasm and the following societies for their co-operation: Calligraphy Space 2001, New York City; Chicago Calligraphy Collective; Colleagues of Calligraphy, St Paul, Minnesota; Friends of Calligraphy, San Francisco; Lettering Arts Guild of Boston; Opulent Order of Practising Scribes, Roswell, New Mexico; Philadelphia Calligraphers Society; Society for Calligraphy, Los Angeles; British Columbian Branch of the Society for Italic Handwriting; Society of Scribes, New York City; The Society for Italic Handwriting, London; Washington Calligraphers Guild; Western American Branch of the Society for Italic Handwriting.

Artwork by Robert Boyajian, Tony Di Spigna, Charles Pearce, Mary Quinault Kossakowski, Marcy Robinson, John Skelton, St Clair Richard, Patricia Weisberg, Wendy Westover is copyright © 1980 of the respective artists.

While every effort has been made to correctly credit sources apologies are made for any omissions.

Introduction

Letters and words are everywhere about us. They direct and inform us, often so unconsciously that we are unaware of their potency and power, recording the loftiest and most banal thoughts of mankind. And in writing we all make our own, a love letter, a signature, a shopping list, sometimes with care and an eye for beauty, sometimes illegibly. Those letters around us, in the street or on the printed page, are all made and designed by someone somewhere. Only occasionally are these made by hand. The dullness and insensitivity of much mechanically produced lettering, and all letters should be gay or sad, exuberant or restrained, or whatever is appropriate to a particular situation, is a sad comment on our times. Yet in so many other ways we live in times that are vigorous and individually vital.

This book is concerned with handmade lettering and calligraphy, some 'one off' pieces of work executed for a particular person or place, some made for reproduction to appear multiplied in many hundreds or thousands in a particular context. That the book has been published is a reflection of the widespread interest in handmade lettering in many parts of the world. More and more people are turning to the sensuous enjoyment of the manipulation of tools and materials in the creation of written and lettered things, physical expressions of intellectual and tactile responses to words and lettershapes.

In this book will be found many and varied examples of lettering in a number of media, parchment, paper, stone, glass, metal and wood, made by a number of craftsmen from many countries, of all levels of experience and expertise. There is work by professional craftsmen and letterers, some of whom have studied and practised their craft for many years, as well as work by enthusiastic amateur craftsmen who, though some may lack the expertise of the professionals, yield nothing in freshness and enthusiasm for their work. This is important because although a professional artist with a skill developed from everyday familiarity with his tools and materials may be capable of producing work with a verve denied the amateur, the amateur unfettered by financial pressures may allow himself to consider work at leisure, its problems and possibilities, and to experiment with techniques and materials in a manner denied the professional.

The reproductions of the work given in this book have been divided into three parts, original lettering and calligraphy, work cut or incised into stone or other material, and lettering made specifically for reproduction. All the work has been carried out since 1976. It must be remembered that each category possesses different qualities and that some of these are bound to be lost in reproduction.

The work made for reproduction, as might be expected, shows best in the book and it is the only work that originally may have been worked upon larger than the size it was designed to appear. It is also the only work that might have been carefully built up, parts added or removed and otherwise altered until judged ready for use. In this way handmade lettering for reproduction can lose something of the qualities of being handmade and present a misleading impression of perfection of finish.

The original calligraphic work loses most in reproduction as the very qualities that are most valued in it cannot be reproduced. The potency of the artist's hand, the actual strokes of pen or brush on skin or paper, will cast a spell over the spectator. The subtlety of the intimate relationship between object and spectator will always differ from person to person according to light and mood, but these can only be enjoyed in front of an original. But then the last is true of any lettered object whether made for public display or private enjoyment.

Much of the work in the book reveals the influence of the broad-edged tool, although some has certainly been made with other instruments and the range of tools and materials now available is far wider than ever before. The book therefore shows in an accessible form a wide variety of works in different media and reveals some of the present preoccupations of a number of lettering artists, their models and modes of expression. The book will provide both enjoyment, and information and, perhaps, inspiration, for although the student will always derive encouragement from contemporary work it should be pointed out that the artists themselves may have used an extensive and varied range of models, from the past as well as the present. The secret behind much of the best work lies not so much on 'how can I do something' but rather on 'what do the words demand'. 'what do I want to do' and only then 'how can I do it'. The work in this book will allow you to see something of the recent results of this process and show you that lettering can be an art as well as a craft, its applications as versatile and as variable as the mood or needs and the skill of the artist dictate.

Michael Gullick and Ieuan Rees, 1980

Calligraphy and lettering

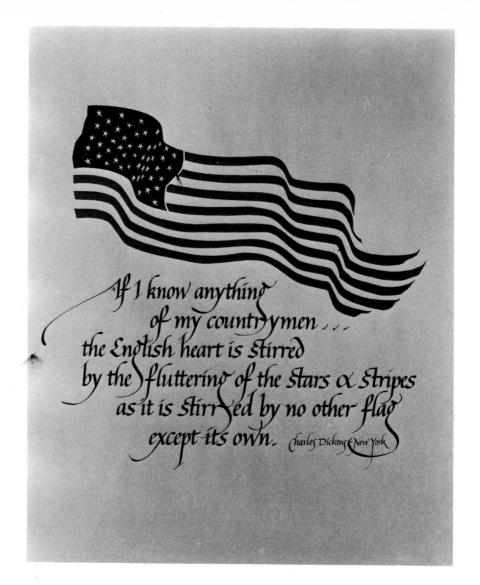

Stanley Knight

'Stars and Stripes'. Blue and red on white paper. Original size 38×33 cm (15 \times 13 in).

Jean Evans

The Baker in *Hunting of the Snark*, 'Intimate Friends'. The large lettering is written out in purple and silver watercolour, the small lettering in vermilion. All on tan paper. Approximate size of original 20.3 × 61 cm (8 × 24 in).

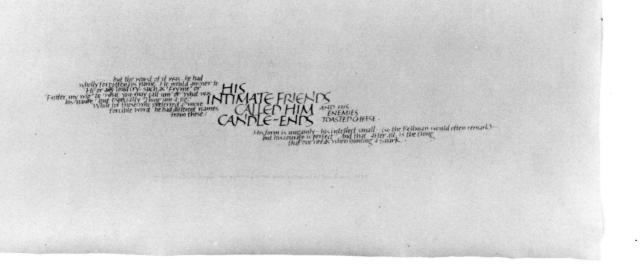

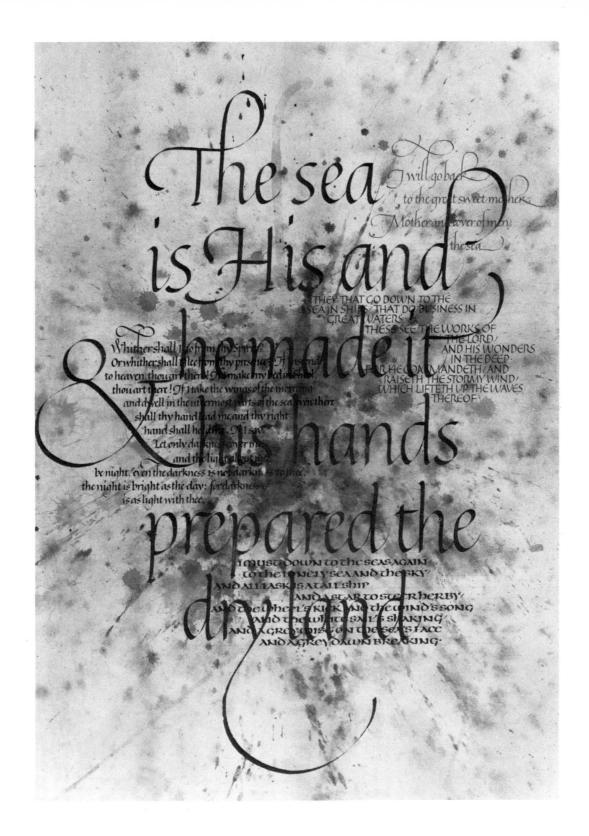

Charles Pearce

'The Sea'. Written out in coloured inks, stick ink and gouache on handmade paper.

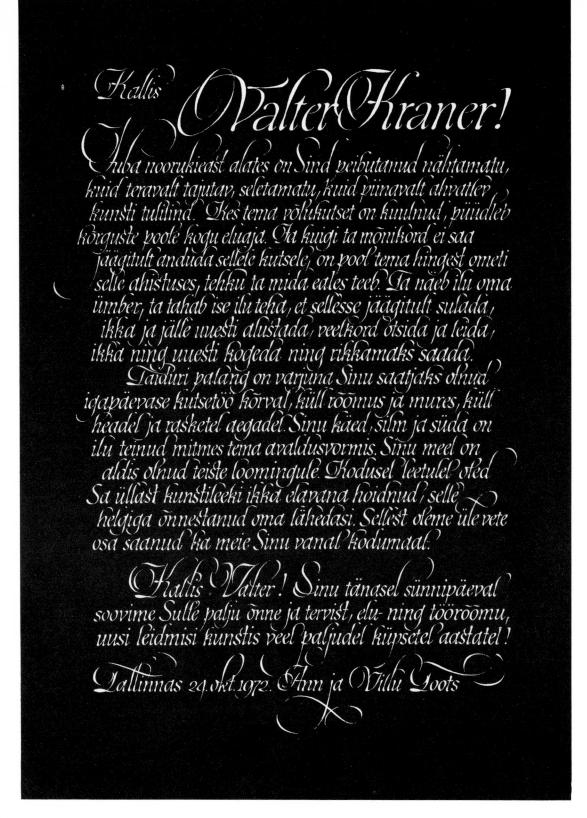

Villu Toots Address to Valter Kraner. Original size 24.7 \times 18 cm $(9\frac{3}{4} \times 7\frac{1}{4} \text{ in})$. WE SHALL NOT cease from exploration

And the end of all our exploring to arrive where we started & KNOW the place for the first time

Through the unknown, fremembered gate when the last of earth left to discover which was the beginning;

AT THE SOURCE of the longest river

The voice of the hidden waterfall

And the children in the apple tree

Not known,
becausenot looked for

But heard, half heard, in the stillness

Between two waves of the sea.

QUICK NOW, HERE, NOW, ALWAY

A condition of complete simplicity

[Costing not less than everything]

And ALL SHALLBEWELL and

All manner of thing shall bewell when the tongues of flame are in folded Into the crowned knot of fine And the fine and the rose are ONE.

from Four Quartets' by TS Eliot

Stanley Knight

Framed panel written in various shades of green and blue on hand-made paper. Original size 40.6×20.3 cm (16×8 in).

V CUIBAGUL CACULO IL CACUL

Jovica Veljovic

Lettering. Written out in ink with a wooden stick on paper. Original size $19 \times 38 \text{ cm } (7\frac{1}{2} \times 15\frac{1}{4} \text{ in})$.

Jerry Kelly and Julian Waters

Quotation from the book of *Genesis*. Written out in 23 carat shell gold on blue Fabriano Roma paper. Original size 19×18.7 cm $(7\frac{1}{2} \times 7\frac{3}{8}$ in).

AND GOD SAID·LET US MAKE MAN IN OUR IMAGE· AFTER OUR LIKENESS· GENESIS

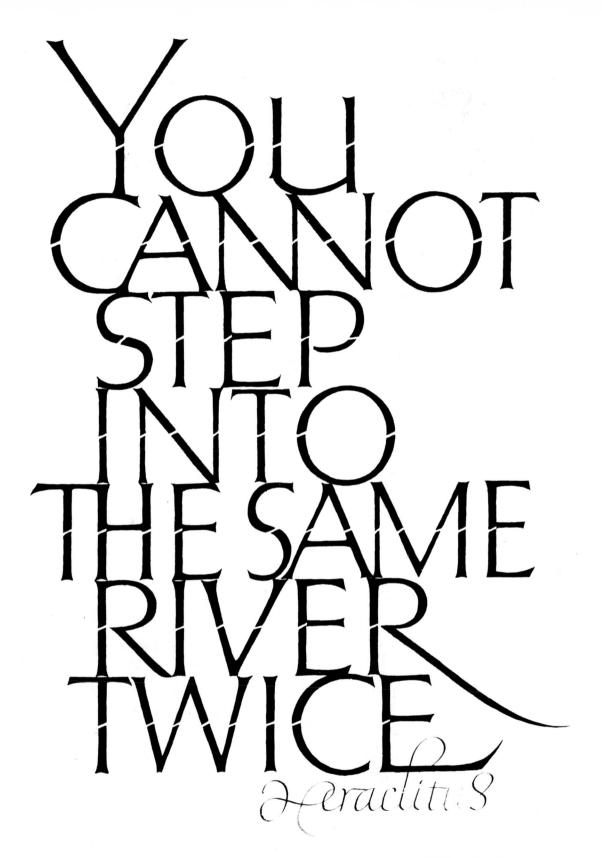

William Metzig Quotation from Heraclitus. Written out in watercolour and ink on paper. Original size 36.8×27.9 cm ($14\frac{1}{4} \times 11$ in).

The Hovers for the Chateaubnand— the clouds in the Chateaubnand— the sun 18 and 18 a

Marcy Robinson

Lettering written out in liquid stick ink with a Speedball and William Mitchell nibs. Original size 15.2 \times 37 cm (14 $\frac{5}{8}$ \times 6 in).

Wendy Westover

Arms of the conservators of Wimbledon and Putney Commons. Written out in gouache, matt gold and India ink on grey Ingres paper. Original size 30.4×25.4 cm (12 × 10 in).

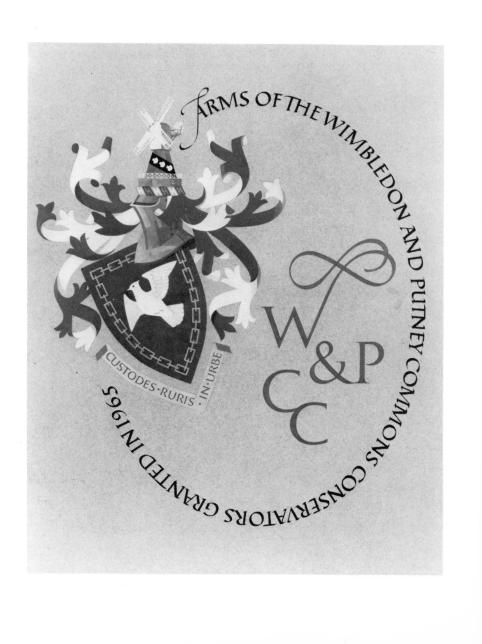

¿En qué reino, en qué Conjunción de los astros, Que el mármol no ha salvado, Y singular idea de

SONETO DEL VINO

siglo, bajo qué silenciosa en qué secreto día surgió la valerosa inventar la alegría?

Con otoños de oro la inventaron. El vino
Fluye rojo a lo largo de las generaciones
Como el rio del tiempo y en el arduo camino
Nos prodiga su música, su fuego y sus leones.
En la noche del júbilo o en la jornada adversa
Exalta la alegría o mitiga el espanto
Y el ditirambo nuevo que este día le canto
Otrora lo cantaron el árabe y el persa.

Vino enséñame el arte de ver mi como si ésta ya fuera ceniza en propia historia la memoria.

Jorge Luis Borges

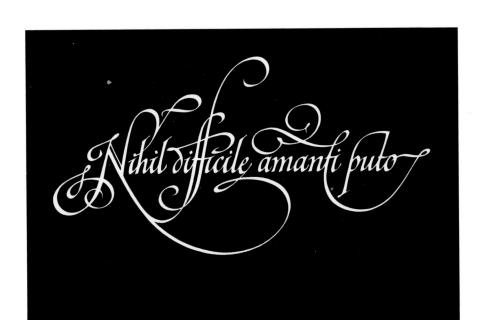

Claude Dieterich

Soneto del Vino a poem by Jorge Luis Borges. Black India ink on white watercolour paper. A fountain pen was used for the text and a steel pen for the illustration. Overall width of lettering $43 \text{ cm } (16\frac{3}{4} \text{ in})$.

Jovica Veljovic

'Nihil difficile amanti puto'. Original size 15×22 cm $(5\frac{7}{8} \times 8\frac{1}{2}$ in).

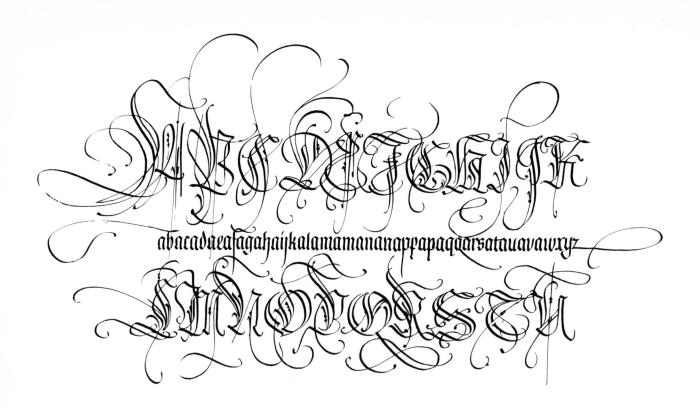

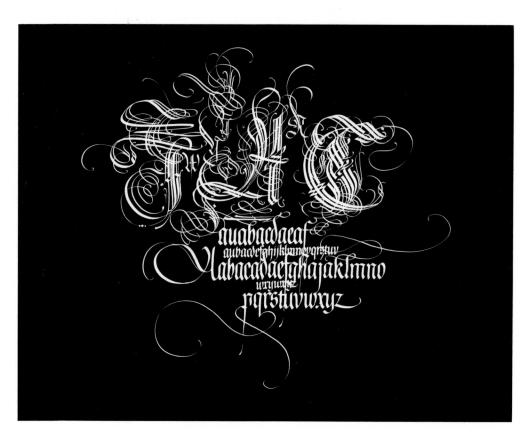

Raphael Boguslav Two highly decorative calligraphic alphabets written out in ink on paper. Original size 35.5 × 43 cm (14 × 17 in).

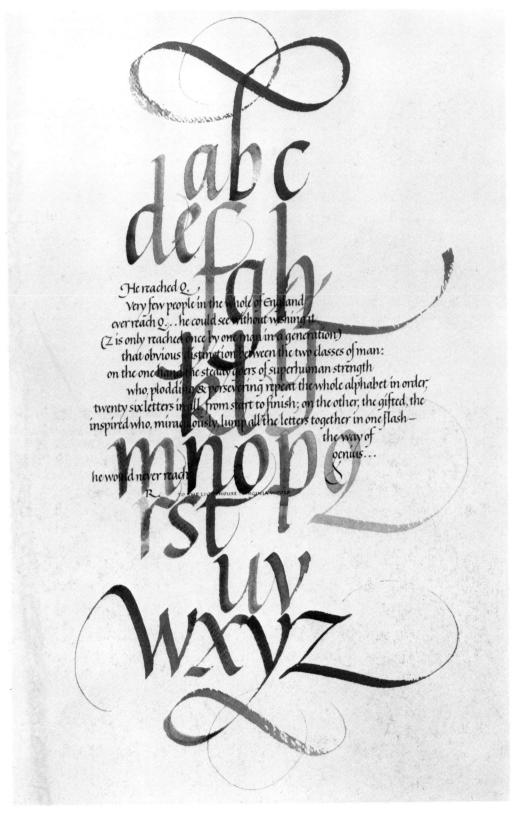

Charles Pearce

Quotation from *To the lighthouse* by Virginia Woolf. Written out in watercolour on Strathmore watercolour paper.

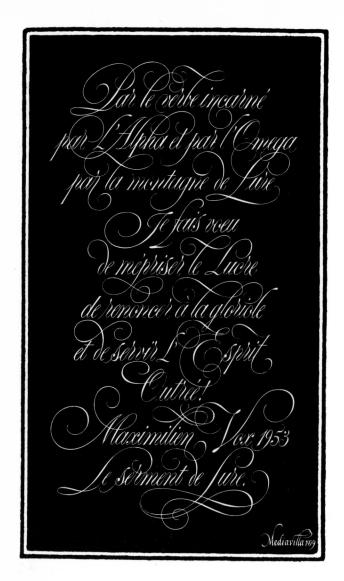

It droppeth as the gentle rain from heaven

Upon the place beneath: it is twice bless'd;
It blesseth him that gives and him that takes:

Tis mightiest in the mightiest it becomes

The throned monarch better than his crown;

His scapter shows the force of temporal power,

The attribute to awe and majesty,

Wherein doth sit the dread and fear of kings;

But merely is above this scaptered sway;

It is an attribute to God himself;

And earthly power doth then show likest God's

When merely seasons justice.

Claude Mediavilla

Calligraphy for Lure's Oath. Original size 32×50 cm $(12\frac{3}{4} \times 20$ in).

Guillermo Rodriguez-Benitez

Quotation from Shakespeare's *The Merchant of Venice*, Act IV Sc I.

Alfred Linz

Quotation from Sigmund Graff. Overall width of original lettering 22.5 cm (9 in).

die freundschaft
ist eine Kunst
der Distanz
so wie die Liebe
die Kunst der Nähe ist.

Sigmund Graff

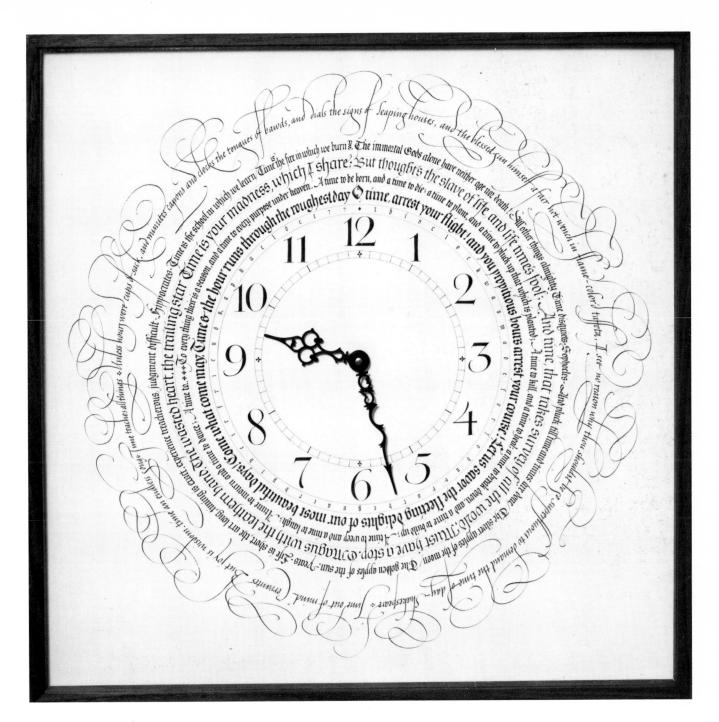

Raphael Boguslav

Clock with walnut frame and battery movement. Original size 48.4×48.4 cm (22 × 22 in).

Courtesy, Jon Henauer.

Stanley Knight Christmas greetings.

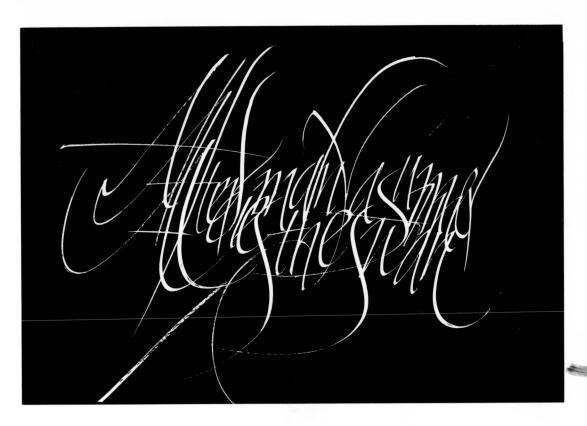

Raphael Boguslav

'After many a summer dies the swan'. Written out in black ink on white paper. Original size 45.7 × 61 cm (18 × 24 in).

Tajkenne kein anveres Zeianen ver Chrehegenheit als die Gute. Toistoi

Alfred Linz

Quotation from Tolstoi. Overall width of original lettering 15 cm (6 in).

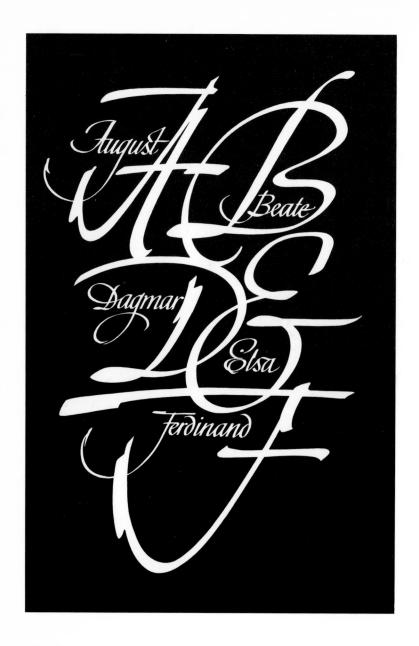

heman who has seen has been present Ralph Waldo Emerson

Villu Toots

A sample page from a book of Calligraphic Studies. Written out in white gouache on indigo paper. Original size 23×15 cm (9 \times 6 in).

James W McFarland

Quotation from Ralph Waldo Emerson.

Jean Evans Alphabet.

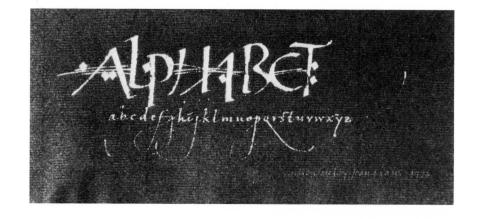

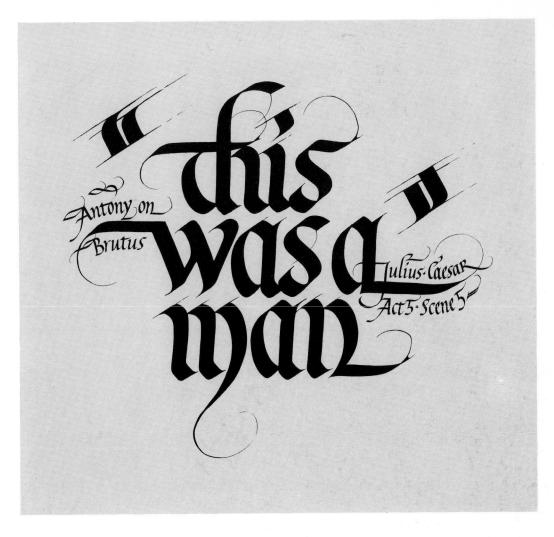

SHOLD BE THOUGHTS WHICH TEN ** COMEO & GULLET ** TIMES FASTER GLIDE THAN THE SUN'S BEANTS

Ieuan Rees

Quotation from Shakespeare written out in black and sepia. Overall width of original lettering 16.5 cm ($6\frac{1}{2}$ in).

Patricia Weisberg

Lettering written out on Spunfelt paper. Original size 28×35.5 cm (11 \times 14 in).

nature of God is a circle of which the centre is everywhere is nowhere.

Ieuan Rees

Demonstration piece done while Artist in Residence at Ysgol Eifionydd, Porthmadog, North Wales. Colour: vermilion. Diameter of original 18.4 cm (7¼ in).

Paul Maurer

Lettering written in watercolour with metal pens. Original size 28 \times 43 cm (11 \times 17 in).

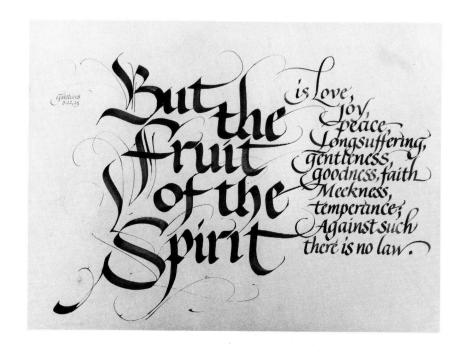

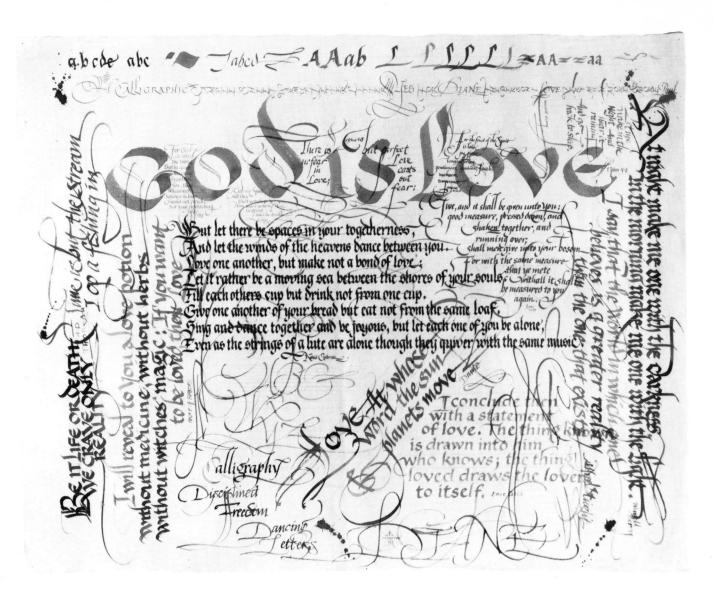

AM

Paul Maurer

Lettering written in watercolour with metal pens and plastic quills. Original size 51×76.2 cm (20 \times 30 in).

Jeanyee Wong

Two monograms.

HERMANN RITTER

Alfred Linz

Quotation from Hermann Ritter. Overall width of original lettering 17 cm $(6\frac{3}{4} \text{ in})$.

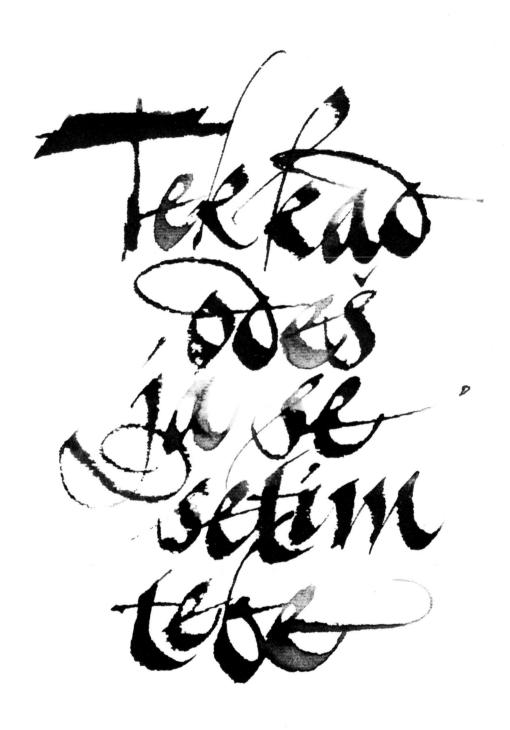

Jovica Veljovic Lettering. Written out in ink with a wooden stick on paper. Original size 20×28 cm $(7\frac{3}{4} \times 11$ in).

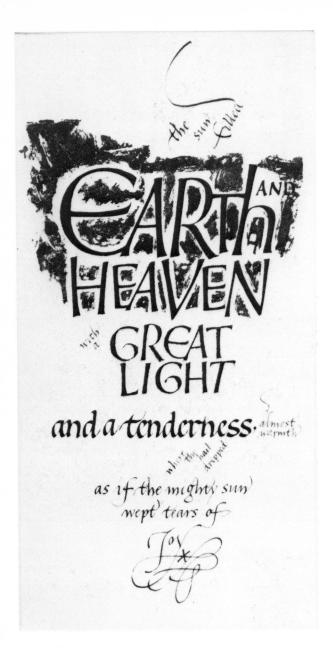

Ann Hechle

Quotation from *March* by Edward Thomas. An attempt to bring out the sound shapes of 'Earth and Heaven' and the intimate quality of the second half of the stanza. Written out in raised and burnished gold leaf and burnished gesso, blue and brown watercolour and stick ink with quills.

David Williams

1 Corinthians, Chapter 15, verses 51-52. Original size 53.5×17.7 cm $(21 \times 7 \text{ in})$.

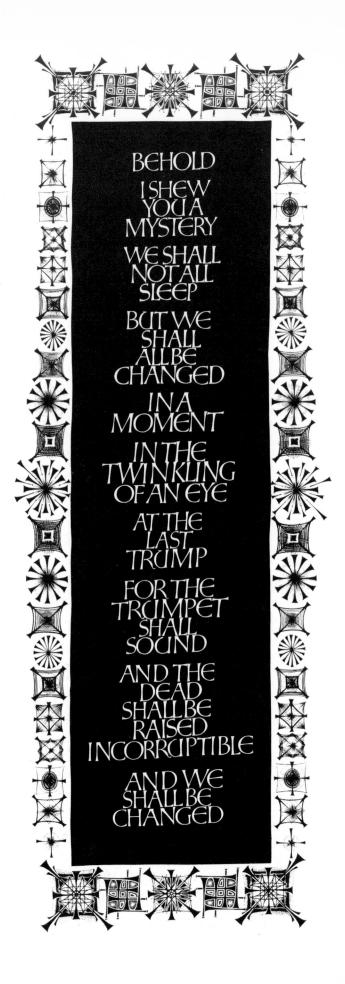

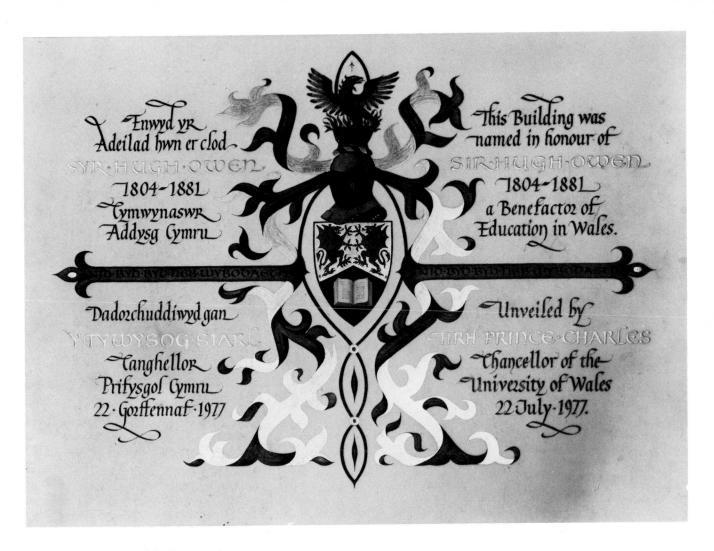

Ieuan Rees

Bilingual gilded vellum panel for 'The Hugh Owen Building' Aberystwyth. Original size 53.3 × 76.2 cm (21 × 30 in).

Hella Basu

Sumer. A thirteenth-century poem from The Oxford Book of Verse. Written out in gouache on charcoal paper. Original size 50.8 × 76.2 cm (20 × 30 in).

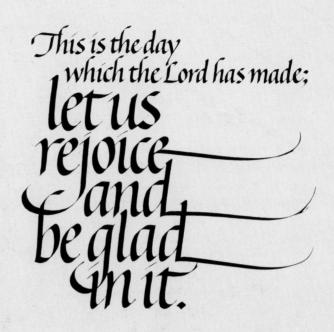

PSALM 118:24

Jeanyee Wong

Psalm 118 verse 24. Lettering written out in black ink on yellow paper. Overall width of lettering approximately 16 cm $(6\frac{1}{4} \text{ in})$.

I Morris

Quotation written out in orange and brown gouache on pale apricot ingres paper. Original size 29.2 \times 43 cm (11 $\frac{1}{2}$ × 17 in).

You cannot prosper by discouraging thrift; quotation by you cannot strengthen the theak by theakening the strong; you cannot help the poor by destroying the rich; 1865

You cannot keep out of trouble by spending wore than you cannot build character and courage by taking atting a wan's initiative and independence. Abraham Lincoln

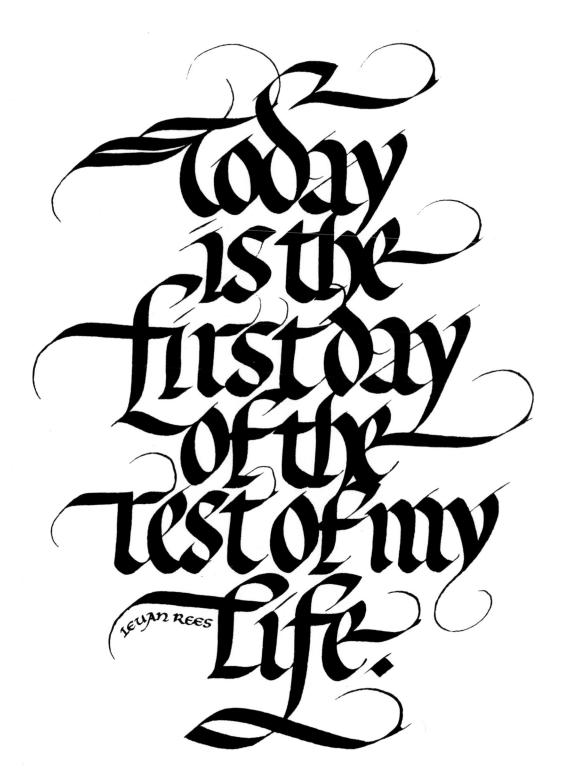

Ieuan Rees

Freely written quotation in black. Approximate size of original 18 \times 14 cm $(7 \times 5\frac{1}{2} \text{ in})$.

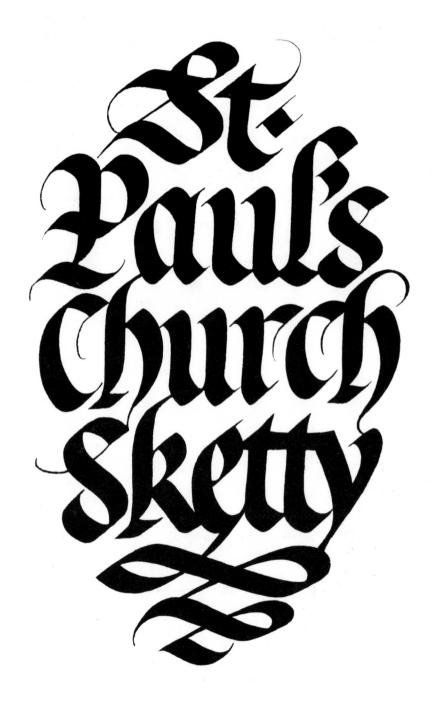

Ieuan Rees

Artwork. Originally gold-blocked on to a leather bound book. Lettering actual size.

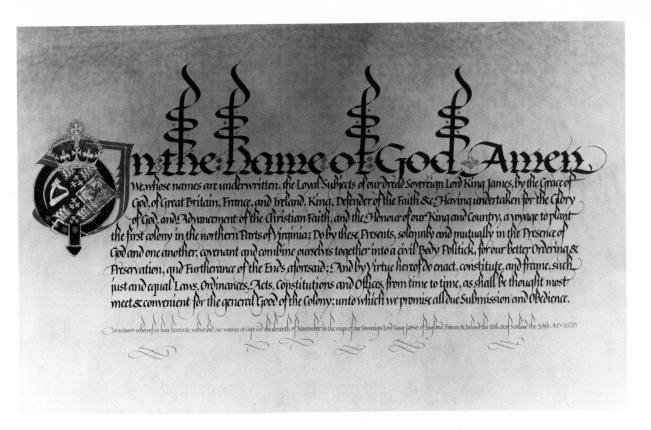

Had there been no calligraphy, how would the bright meanings and soul enriching thoughts flower 20 2201 was

Charles Pearce

The Mayflower Compact. Gold leaf, ink and gouache on hand-made paper. Original size 25.4×43 cm (10 \times 17 in).

Patricia Weisberg

Quotation from Qadi Ahmad. Written out on Strathmore paper in coloured inks with Bouwsma pen and $2\frac{1}{2}$ pt Mitchell nib. Letters in brown and green, quotation in brown and author's name in green. Original size 35.5×43 cm (14×17 in).

THE WOODS DECAY,
THE WOODS DECAY AND FALL,
THE VAPOURS
WEEPTHEIR BURDEN
TO THE GROUND,
MAN COMES & TILLS THE SOIL
AND LIES BENEATH,
AND AFTER MANY A SUMMER
DIES THE SWAN.

TENNYSON

John Prestianni

Quotation from *Tethonus* by A F Tennyson. Brush lettering on vellum. Original size 40×58.4 cm (16×23 in).

Facing page: 'The Scribe' by St Columba. The writing is based on the Anglo-Saxon styles of the 7th and 8th centuries AD. Written out in ink and illuminated with watercolour. Original size 76.2×53.3 cm $(30 \times 21$ in).

Bryan Winkworth

Poem *Manasija* by Vasko Popa. Written out in black ink on white paper. Original size 28×38 cm (11 \times 5 in).

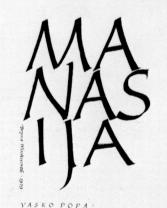

Blue and gold Last ring of the horizon Last apple of the sun

OH ZOGRAF HOW FAR DOES YOUR SIGHT REACH DO YOU HEAR THE NIGHT HORSEMEN Allah Il Ilallah

YOUR BRUSH DOES NOT TREMBLE YOUR COLOURS ARE NOT AFRAID THE NIGHT HORSEMEN COME CLOSE

THE NIGHT HORSEMEN COME CLOSER Allah il ilallah

on zograf what do you see in the night's depth Gold and bluc Last star in the soul Last infinity in the eye

AH MERIOHAIDE

The scribe by sant columba, called colum-cille

Auto Columba, the Treat push missionary of the sixth che monastery of Jona off the monastery of Jona off the coast of Social who was borning Junthe mointeaus of Donezal, and was baptised by the name Colum, which, in Latin, becomes Columba, of the dove Latin Generalle, of Jove of the chuych he had a Treat of the chuych the hada Treat of the though so so public, so much so that Latin soupled more than the transcribed more than the transcribed more than the thindred opies of the Joseph's inhisonn hand to its said that the Book of Dippon, probably written in the Eighth certapy, we of Columba's hand.

e was highly educated and belonged to the leapined opderogy lyush poets, the pulud as a pesulte of his pepuration as a poet, a number of

poems of much later date have been attributed to him, such as the one transcribed here. In sei, while visting his old master, timbar of Moville, he clandestinely copied a codex of the tospels populae own use. Upon discorping this, finbar, to whom the book belonged, anguly brought the matter bepope the high king, de-

the marrey bepope the high king, demanding setzupe of the copy. The king puled against Columbia, saying, to every you ow belongs here cale, a to very book its sonbook, "establishing with this pronouncement, possibly pop the first the pronouncement, possibly pop the first the law of copying the According to accounts left us of his lye, Columbia, in vindication for the judgment that had been pendered against him, instanced the battle of Cul Dreume, and many lives were lost.

s penance, columba lext Jpeland.

To live in exile pop Christ." In

563 he established the pamous

and incluencial monascepy or

Jona, whose some people think the

Book of Kells might have been mutter,

late in the eighth certify; pom

whence, conceivably, it might have been

when the monascepy was sacked by

viking invasion, speland had only been converted to Christ

Viking imasion, Jieland hadonly been conveyed co Chyustiantey a little longer than a century when Columbapounded his monastery on Jona. Bite prom the puper, Jush monasterism had embraced universal learning, that is, pagan and classical as well as Chyustian lope, unlike that of the Continent, which, until the beginning of the syste century concepted itself primapily with learning which pelated to the superial side of monastic life. Lidvis Bielep, in IRELAND, HARBINGER OF THE MIDDLE AGES, says that

Is sich mo chrod ou scridauu;
un organu mo gless geroll;
sceichto penu-guldan caeloa.
org uvaeloacoo vud glegorm.
Brunuto sim u-cena uvedauru
as mo laim vegounuu vesmais
vontav a vig por vuillinu
do vud in chuillinu chuesglais.
Sinim mo phenu mdec mdriach
car aenach ledar ligoll
cen scor pri selba segonu
viau seith mo chrodon scridonu.

te was perfectly natural that the firsh, having become Christians, should be as appreciative or the new learning as they had been or they own truditional lope. This activities is chapactery is the year physional posterior of firsh had got the word is manufes teld most impressively by the fact that they developed a style of handryuting all they own, a national seque.

he push, op unsulap, half-uncial as me know it today is pe gapded as being a development of sepipes poin antiquity, most likely of a continental half-uncial rapidey, which we pe byouther to peland by the explicit to peland by the explicit missionapies. The push & lately angle saxon hands differed in this pespect poor to be peped, primary examples appead, primary examples are period, primary examples are period, primary examples.

ples of which are the merovirgian, visigothic, & Beneventan scripts, as these are thought to have been attempts to populate a mixtupe of half-inicial and local captive hands. Bitley says: "Of all the numerous types of Latin script which came unto existence digning the capty middle ages, the prish script had the longest

ages, the push separt had the torgest lape and the widest dissemination. All the other ancient national separs or Europe had to give may to the supernor qualities or clapity and practicability of the capoline miniscule. Even when, with the conqueryors and the Contendental pelicious opiders, Romanesque and Gothichards had come into use, the ancient push separe continued to be employed for the nature of tests in the pushlanguage, and is so employed to this day."

ophaps many of the speat manus scripes of the severthes eighth certificity of viking imasions which in the sweep of viking imasions which in the numb certificity oblives acted the Celtic civilization of Northimbra. In looting the pich and important monastryes, the unadeps cappied of the lighty elaborate codices which were prequent

the unadaps capped our monastifues, the unadeps capped op; the highly elabopate codices which were prequently decopated a landly covered with precious metals of sivels. Among very pew others which have been preserved, the Lindispaped Gespels, the Book ox Kells, and the Book ox. Duppov stand out as masteppieces of sopial ape. The motives and images of the pasturipies of sopial ape. The motives and images of the pasturipies and Anglo-Saxon cultiples, established and developed in metals option and stone capping, were translated by Christian incluence into the illimination adopming these books. For us, they are indeed a testament to the vision of their scribes.

A unceasing stream of wisdom pours frommy brown hand. It spills its flow of ink from the blue-skinned holly over the page. I send my we thatle penovera whole fair of lovely books Without ceasing for the wealth

of Treat ones, and so my hand is tiped from writing.

37

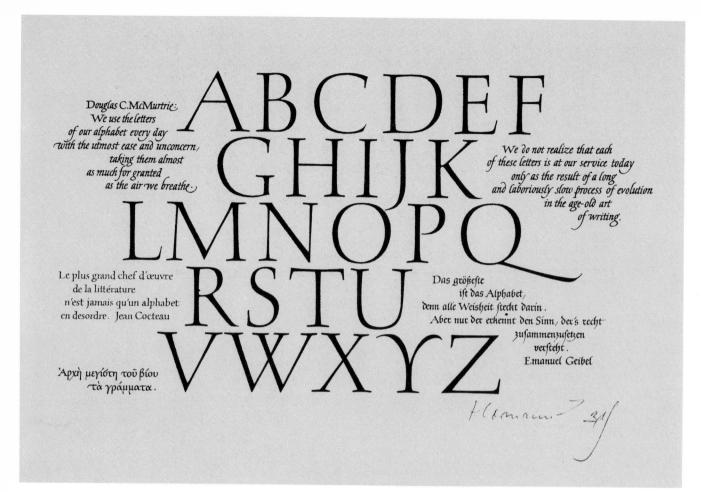

Hermann Zapf

Alphabet with quotations. Commissioned by Philip Hofer. The Houghton Library, Cambridge, Massachusetts.

Joan Pilsbury

October by Edward Thomas. Written out in black, green and burnished gold on vellum. Green and gold title. Double page size 30.4 × 35.5 cm (12 × 14 in).

OCTOBER Edward Thomas.

he green elm with the one great bough of gold L ets leaves into the grass slip. one by one. -The short hill grass, the mushrooms small, milk-Harebell and scabious and tormentil, whi That blackberry and gorse, in dew and sun, Bow down to; and the wind travels too light To shake the fallen birch leaves from the fern; The gossamers wander at their own will. At heavier steps than birds the squirrels scold The rich scene has grown fresh again and new As Spring and to the touch is not more cool Than it is warm to the guze; and now I might As happy be as earth is beautiful, Were I some other or with earth could turn In alternation of violet and rose, Harebell and snowdrop, at their season due. And gorse that has no time not to be gay. But if this be not happiness, -who knows? Some day I shall think this a happy day. And this mood by the name of melancholy Shall no more blackened and obscured be

MIHICREDE RESSEVERA Glaube mir. eine ernste sache ist eine EST wahre Freude VERUM GAUDIUM SENECA

Rhythm is in barmony with nature and exists with manifold efficacy and form within all living creatures and within the phenomena of movement which furround us in the regularity of our beart and pulfe beats in our breathing; or in the repetition of forms with like effects in plants of the fame kind-everywhere we feel the rhythmical law of renewal. Xs a temporary phenomenon of a rule. in continuous change we recognife lettering also as rhythmical form.

The flowing movement in writing may be compared to the undulation of waves of water. When we observe waves with their stronger and weaker of allations we have a full rhuthmical exherience. The observation of this movement can dive us the completed film but the

and weaker of illations we have a full rightmical experience. The observation of this movement can give us the completed film but the fingle photograph showing only the right fragment of one event can never do so. So it is with writing the writer has the ribythmical experience whilst the beholder of the written matter can only gues at the vivacity of the letter strokes. An attempt to draw the movement of the wave refults in the wavy line. By circumscribing the up and down movement of the mountains and valleys of the waves we get the ribythmical experience. But if we draw in such a way that the mountains and valleys in the waves barmonise exactly in their reversed form, then the vivid impulse of the movement is destroyed, and is replaced by a mechanical form.

Thefe explanations as to the nature of rhythm clearly illustrate the immente value of the band written letter as against the defigned form, for no defigned form or type-fet line can bear comparison in rhythmical strength with the affect of the written line. Though, to be fure, we notice in type-fet letters a certain barmonious effect, given by the proportional balance of spaces, yet the rigid repetitive effect of absolutely equal characters cannot give to the whole appearance the livelines of rhythmical undulations. Just as in the fine arts, spontancity appeals to us more strongly than the composition which is deliberately constructed so lettering written freely with feeling takes precedence over any designed form of lettering.

WALTER KACH-RHYTHM IN LETTERING

Werner Schneider

Two pieces of calligraphy on Fabriano paper. Original size 48.2×66 cm $(19\frac{1}{2} \times 26$ in).

MARIANTA

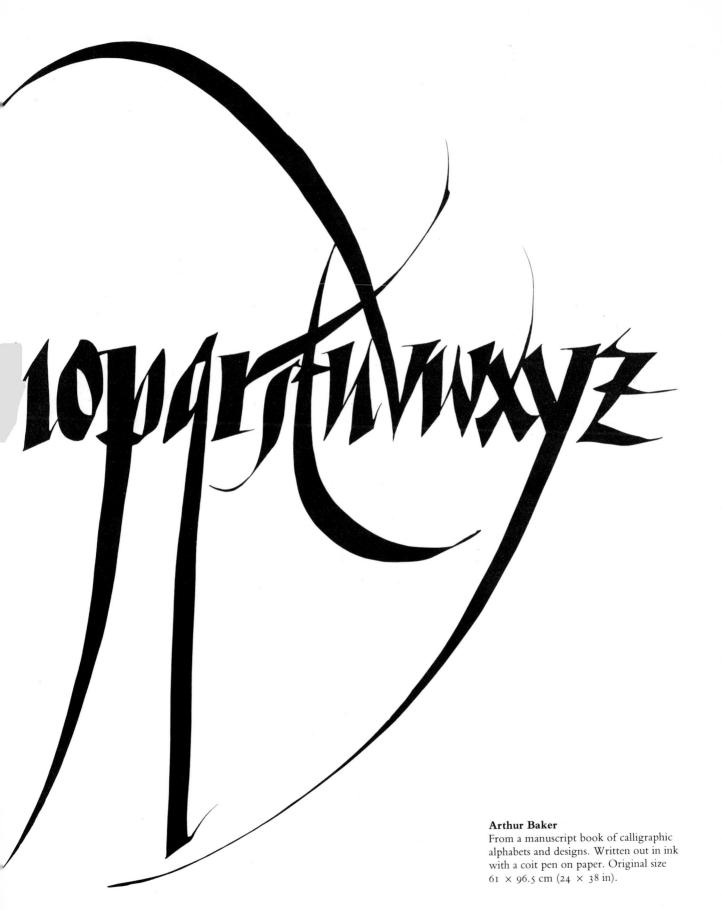

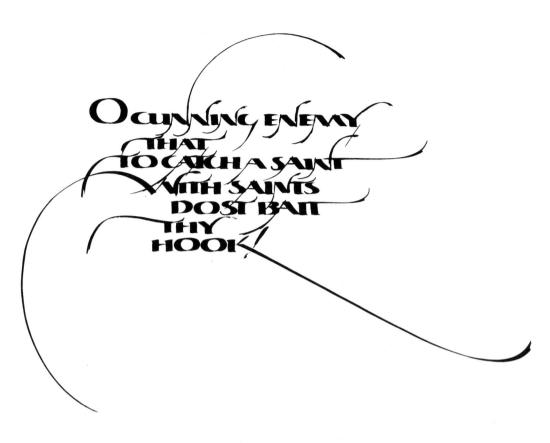

Angelo in Measure for Measure, act2, scene2

Nancy Culmone

Lettering written out in ink with a William Mitchell and automatic pen on paper. Overall width of lettering in original 18.5 cm $(7\frac{1}{4}$ in).

John Woodcock

Brush drawn alphabet. Coloured inks and resist on handmade paper. Approximate size of original 38×51 cm (15×20 in).

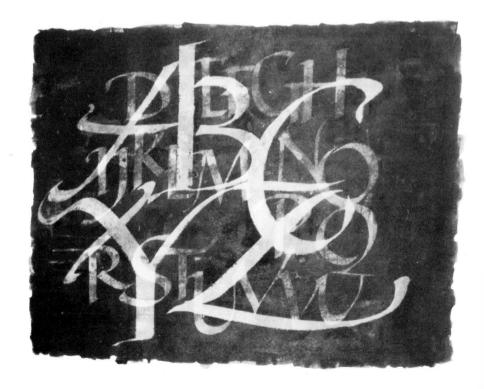

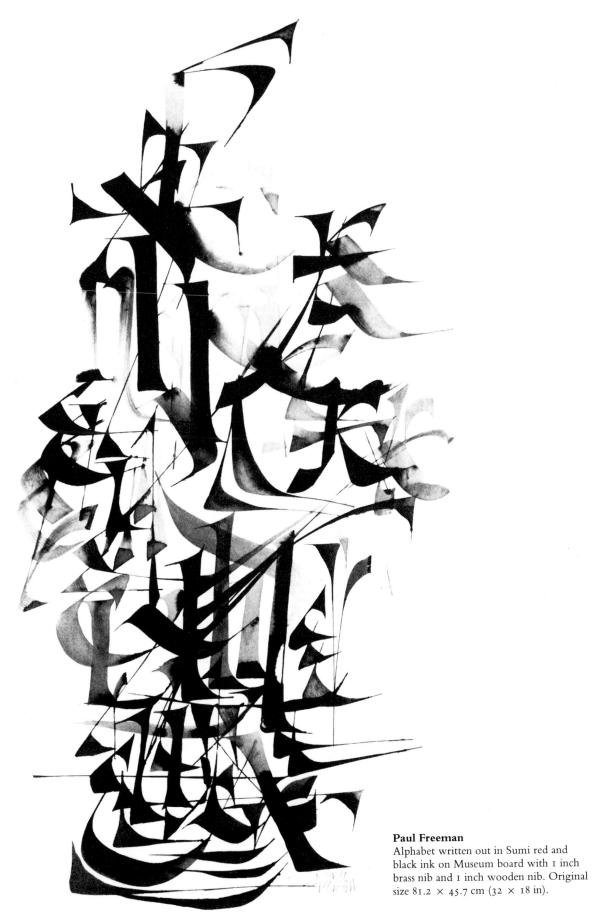

Nancy Culmone Lettering written in ink with a Speedball

pen on paper.

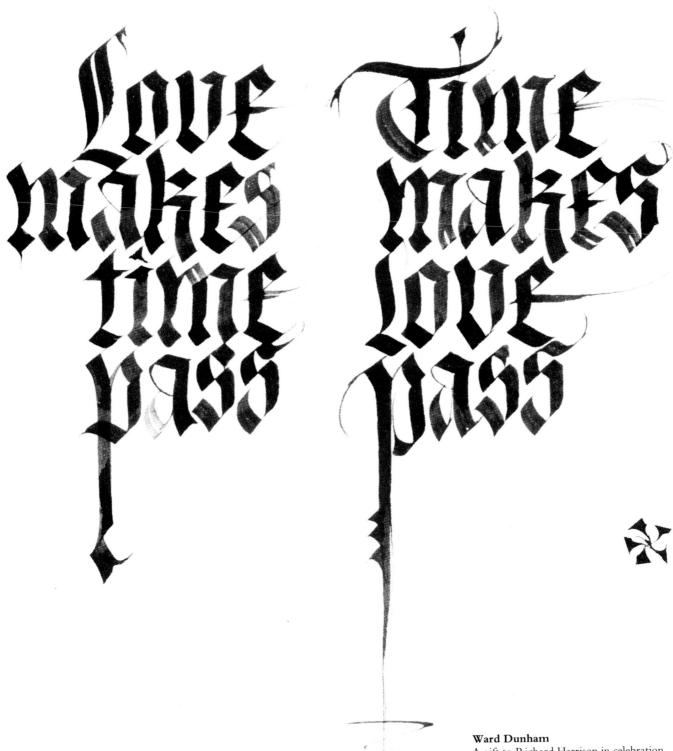

Ward DunhamA gift to Richard Harrison in celebration of his 70th birthday. Written in Chinese ink with a 5 mm Brause nib on Butcher paper.

Robert Boyajian
Freely written alphabet. Written out in sepia and black India ink mixed, with Lozada brass pen on Hammermill Bond.
Original size 43 × 35.5 cm (17 × 14 in).

Arthur Baker Three pen manipulated alphabets.

Qioo decir gue loz amantes del vino serán condenadoz. No hay verdades comprobadas, pero hay mentiras evidentes. Si loz amantes del vino y del amor van al Infierno, vacío debe estar el Paraíso.

Omar Khayyam

Claude Dieterich

A poem by Omar Khayyam. The initial was written in red India ink with reed. The text in black India ink with fountain pen. Overall width of lettering 52.7 cm $(20\frac{1}{2} \text{ in})$.

Jerry Kelly

Passage from the *Anatomy of Destructiveness* by Erich Fromm. Written out in blue and red watercolour, asterisks in black, on Honeysuckle Canson Mitentes paper. Original size 43 × 35.5 cm (17 × 14 in).

Erich Fromm *Today, when almost
everything is made by machines, we notice
little pleasure in skill except perhaps the
pleasure people experience with
hobbies like carpentry or the fascination
of the average person when he can watch a
goldsmith or weaver at his work; perhaps
the fascination with a performing
violinist is not only caused by
the beauty of the music he produces
but by the display of
his skill * from the anatomy of human
destructiveness' 1973

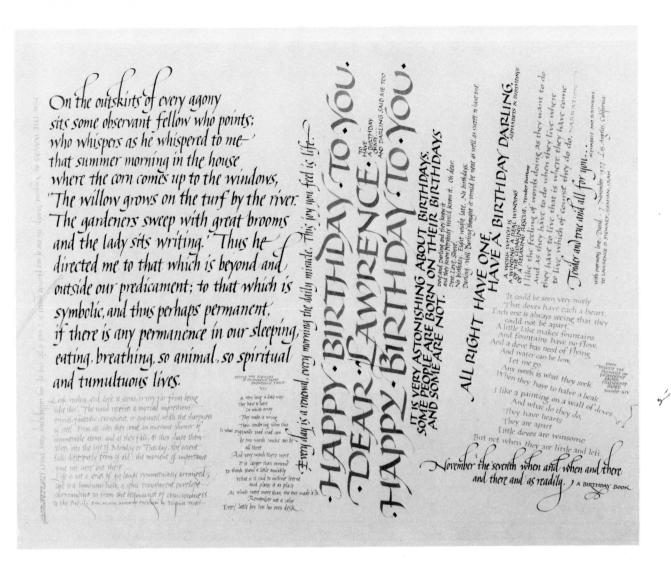

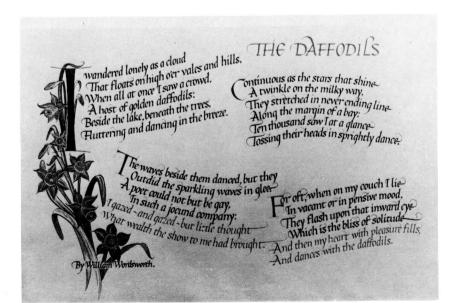

David Mekelburg

A spontaneous unplanned birthday greeting composed of quotations from the works of Gertrude Stein and Virginia Woolf. Written out on Bodleian mouldmade paper in black Chinese stick ink, vermilion Japanese Sumi ink, and light blue and dark green gouache, with Brause nibs and turkey quills. Original size 52 × 71 cm (20½ × 28 in).

Nancy Winters

The Daffodils by William Wordsworth. Original size 25.5×47 cm (10 × 16 in).

ITIS FORTUNE NOT WISDOM THAT RULES A MANY LIFE CICERO

Stuart Barrie

Quotation from Cicero. Original size framed 38×25.4 cm (15×10 in).

Anne Benedict

Quotation from W B Yeats. Original size 24×18.7 cm $(9\frac{1}{2} \times 7\frac{3}{8}$ in).

WE HAVE LIT UPON
THE GENTLE,
SENSITIVE MIND
AND LOST THE OLD
NONCHALANCE
OF THE HAND,
WHETHER WE HAVE
CHOSEN CHISEL,
PEN OR BRUSH,
WE ARE BUT CRITICS,
OR BUT
HALF CREATE FOOD POMINION SE

RUDOLF KOCH

The following excerpt was written by Fritz Kredel, one of Koch's finest students. Koch and Kredel collaborated on many projects in the Offenbach Workshop. This paragraph is from the introduction to the 1976 reprint of Das ABC Büchlein by Koch.

Koch's desire to be an educator was paramount. He wrote a friend "I am nothing but an educator. Of course, I do not want to educate calligraphers, but human beings." The human relationship was more important to him than the work. His first concern was helping his students to improve themselves, to realize their greatest potentials. To achieve this, he realized he must set an example, and for that he was totally qualified. His reliability and loyalty were irreproachable, his character was noble. In financial matters a handshake or a verbal agreement was all that was ever necessary. 9 He was what I call a real man!

Jerry Kelly

Excerpt from the introduction to the 1976 reprint of *DAS ABC Büchlein* by Rudolf Koch.

This question is one that only a very old man asks. My benefactor told me about it once when I was young. and my blood was too vigorous for me to understand it. Now I do understand it. I will tell you what it is: Does this path have a heart? All paths are the same: they lead nowhere. They are paths going through the bush, or into the bush. In my own life I could say I have traversed long, long paths, but I am not anywhere. Aly benefactor's question has meaning now Does this path have a heart? If it does, the path is good; if it doesn't, it is of no use. Both paths lead nowhere; but one has a heart, the other doesn't. One makes for a joyful journey; as long as you follow it, you are one with it. The other will make you curse your life. One makes you strong: the other weakens you!

FOR ME RE IS ONLY CARLOS CASTANEDA: The Teachings of Don Juan written out by David Mckelbing for Neeme Billawala

David Mekelburg

A passage from *The Teachings of Don Juan* by Carlos Castaneda. Written out with Brause nibs on BFK Rives paper. The small italic writing was done in black Chinese stick ink, the large capitals in Indian red designer's gouache, and the credit lines in grey designer's gouache. Original size 66 × 51 cm (26 × 20 in).

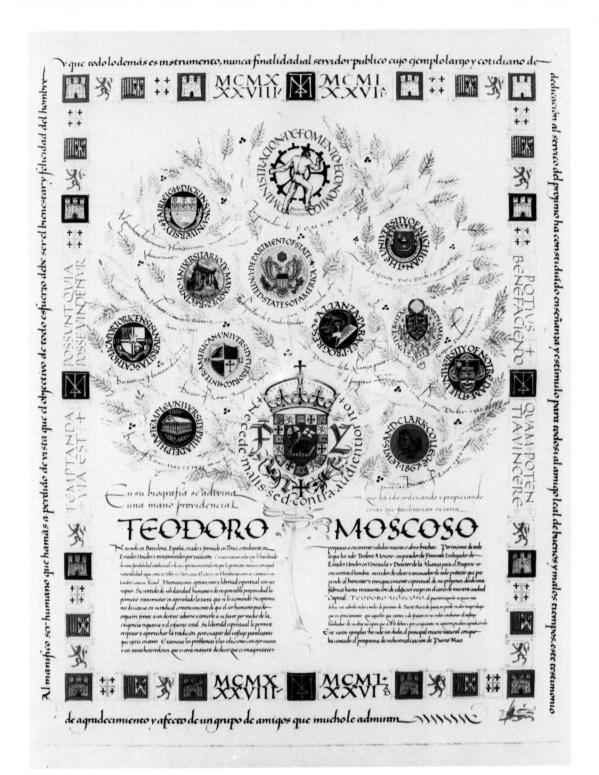

Donald Jackson

Presentation panel to commemorate the public service of Teodoro Moscoso. Written out on vellum in stick ink and pigments, with gesso, gum ammoniac and powder gilding with quills. Original size 66×51 cm (26×20 in). Courtesy, Teodoro Moscoso.

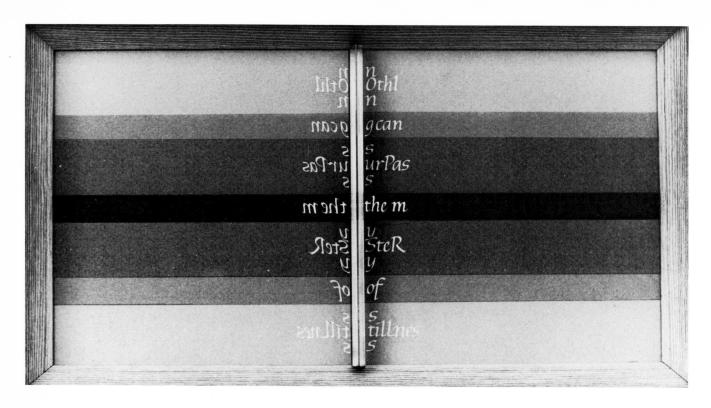

Peter Halliday

Poem 43 from a collection of 73 Poems by E E Cummings. Brush-painted in watercolour on black, light and dark blue and grey paper with a double-sided reflecting strip down the centre. Original size (within frame) 15.2×30.4 cm $(6 \times 12 \text{ in})$.

Reproduced by permission of the agent for the late E E Cummings.

Jean Evans

Lettering. Approximate size of original 40.6×51 cm (16×20 in).

Impressed with the power and value of the written word.

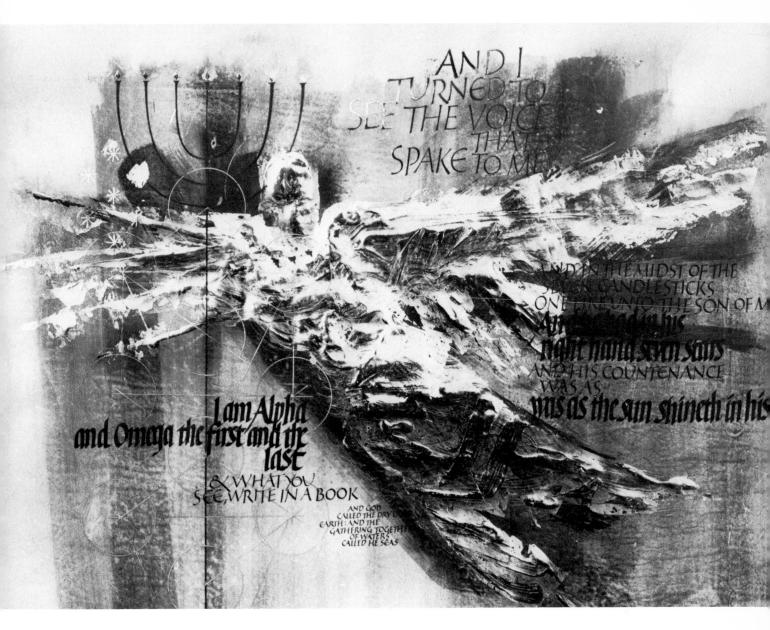

Donald Jackson

Detail from 'I am the Alpha and Omega'. Written out in stick ink, gesso, gum ammoniac, shell gilding and gouache on vellum with quill and sponge. Height of original 33 cm (13 in).

Overleaf

Alison Urwick

Centre pages of a manuscript book presented to Heather Child in 1977 by The Society of Scribes & Illuminators. Written out in green, fawn and powdered gold capitals on india paper. Hand bound in vellum with silk ties, polished stones and silver thread. Actual size.

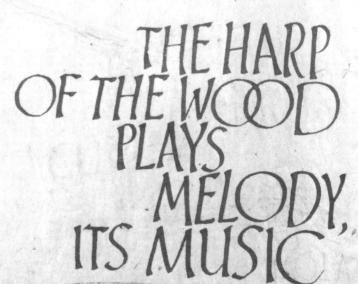

WITH THE WIND BOWED ELDER BOUGHS

LEAN ALL TO THE SWAY

AND THE PLIANT

THROUGH THE LONG AGES IT SINGS TO THE HOST AMELODY THAT IS NOT SAD

BRINGS PERFECT PEACE; COLOUR HAS SETTLED ON EVERY: HILL, HAZE ON THE LAKE OF FULL WATER.

OF THE WILD ELM (THAT SERVES WELL THE BOWYERS) E THE RESISTANT LIMBS
OF THE TOUGH, KNARLED BAKTREE

OF THE TOUGH, KNARLED BAKTREE

IN THE DEEPS OF THE VALLEY WORD PRRELOGUES BRIGHT WITH THE DRREL OF THE HOLLOWS, BY THE PLEASANT MARSHES WHERE THE HINDS OFTEN COME. TOWARDS ONE REALITY

THRESHOLD
AWARD

FOR ANESSENTIAL
CONTRIBUTION
WHICH HELPS LEAD
HUMANITY TOWARDS A
VISION OF REALITY
THAT INTEGRATES
ALL INTO A
SINGLE SACRED
WHOLE

15 PRESENTED TO
LEWIS
THOMAS

THE NINETEENTH DAY OF MAY NINETEEN HUNDREDAND SEVENTYNINE

PRINCE CHAHRAM PAHLAVI NIA Threshold Foundation PRESIDENT DR RAYI RAYINDRA Thisheld Award DIRECTOR

YTOE HHEH АРХН ПРОТ ТОН DECH ITANTA AI' AYTOY ETENETO KAI XCUPIE AYTOY ODE EN O TETO HEN.

KAI H ZWH HH το φως τωμ AHOPOTTON, KAI TO POUT EN TH EKOTIA PAINAI KAI H EKOTIA AYTO OY KATEA ABEN,

TEHETO AHOP WHOE ATTESTA AMENOE TIAPA O EOY OHOMA AYT WIWAHHHE ογτος ηλθεη EIE MAPTYPIAN ІНА МАРТУРНЕН חבףו דסץ שעד OT INA TTANTET

ΠΙΣΤΕΥΣΩΣΙΝ ΔΙ' AYTOY, OYK HN εκειμος το φω I AM IHA MAPT үрнхн пері тоу φωτοΣ ΗΝ ΤΟ ΦωΣ ΤΟ

EH AYTO ZOH HA ALHOINON O DO TIZEI MANTA AN өршпон ерхо MENON EIT TOH KOEMOH.

EH TW KOEMW H Η ΚΑΙ Ο ΚΟΣΜΟΣ Al'AYTOY ETEHE TO KAI O KOEMOS AYTOH OYK ETHW EIT TA IAIA HAO EN KAI 01 14101 AYTON OY TIMPE AABON, OZOI DE EAABON AYTON EAUKEN AYTOI I EZOYIIAH TEK HA BEOY TENES BAI TOIS MISTE

YOYEIH EIE TO O HOMA AYTOY OI OYK EZ AIMATON OYAE EK BEAH ΜΑΤΟΣ ΣΑΡΚΟΣ ODE EK BEAH ΜΑΤΟΣ ΑΝΔΡΟΣ AM' EK BEOY ETEHHHOHEAH OF DIA MUYEENE AT O A OTOE EX PE ETENETO K M EXKHMUTEH EN HMIN KAI EBEATAMEBA THH DOZAH AYTOY AOZAH WE MOHO TEHOYE MAPA MATPOE DEOE O WH EIE MHOGIAT ІШАНННЕ МАРТУР Е ЕЗНГНЕАТО. ET TIEPT AYTOY KAI KEKPATEN AETWH KH MAPTYPIA TOY OYTOE HH OH

EITION O OTTIEW MOY EPXOMENOE емпросоен моу

TETONEN, OTI TI ρωτος Μογ ΗΝ, OTI EK TOY ITAH POMATOE AYTOY HMEIT MANTET EAABOMEN KAI XAPIN ANTI XAPI TOE OTI O NOM EAOOH H XAPIE KAI H AAHOEIA ΔΙΑ ΙΗΣΟΥ ΧΡΙΣΤ OY ETEMETO. BEON OYSEIT E шракен пшпо те моногення 17HE XAPITOL TON KOATION TOY MATPOE EKEINO AI AYTH EXTIN IWANHOY OTE A METTEILAN MP OF AYTON OI 10 YAMON EZ TEPOX

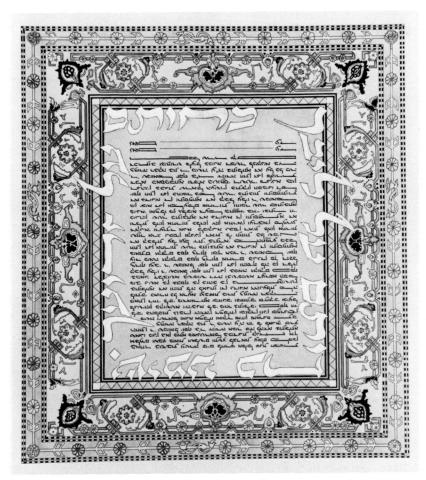

Stanley Knight

Text page of St John's Gospel written in Greek uncials on vellum. The writing in blue and black ink and raised gold. Original size 17.7 \times 25.4 cm (7 \times 10 in).

Cara Goldberg Marks

Wedding contract. Written out in ink and watercolour. Collection Tzipporan Brandes, Hong Kong.

Facing page

Donald Jackson

'The Threshold Award'. A presentation certificate written out in raised gold and black ink on paper. Original size $50 \times 28 \text{ cm } (19\frac{3}{4} \times 11 \text{ in}).$

Minner 40 Manna Wys

Colleen

Graffiti on a wall in Chicago 1971. Original size 63.7×101.6 cm (26 \times 40 in).

Jovica Veljovic

Decorative lettering. Written in ink with a wooden stick on paper. Original size 11.5 × 17 cm $(4\frac{3}{4} \times 6\frac{7}{8} \text{ in})$.

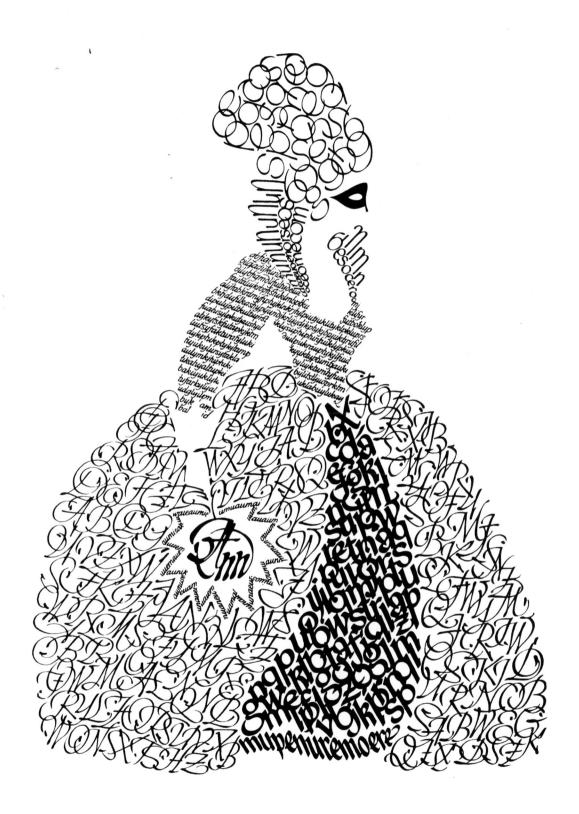

Villu Toots

'Ann'. Experimental page of letters in brown, red and orange. Original size 38.5 × 28 cm (15 × 11 in).

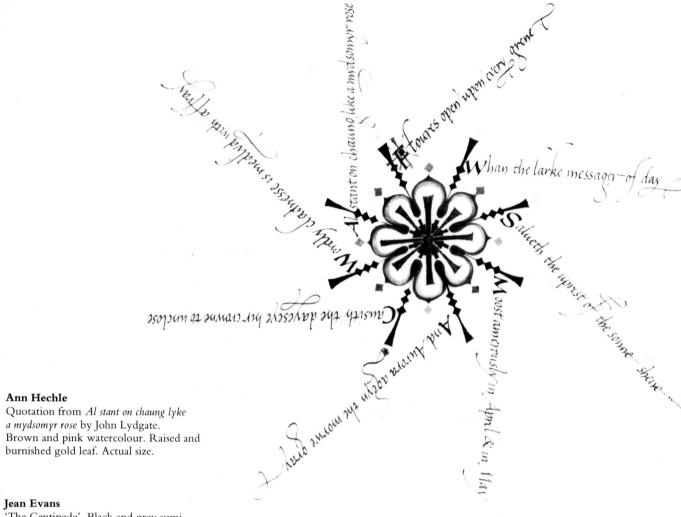

'The Centipede'. Black and grey sumi stick ink and gold watercolour on watercolour paper. Approximate size of original 75 × 250 cm (30 × 10 in).

BUTINTHE Alt OF CAUSIAPIN

ASINALIARTS/THEIDEAINTHEMI/ NDISTHEULTIMATEYARDSTICK BYWHICHWEEVALUATEMERITIN THEART-PRODUCT THETECHNICA Alpre-requisites-tools/MAT ERIALS/ANDMETHODOFWORK/ ING-THOUGHNEEDED/AREALW/ AYSSUBORDINATETOTHEIRME NTALEXEMPLARTECHNIQUEIS ONLYAMEANS'SKILLFULLYIVRO UGHTEXPRESSIONS OF INCONSE QUENTINLIDENSAREMORELIKE LYTONROUSED ISMAYTHANNO! MIRATION POORLYWRITTEN LE TIERSSKILLFULLYCHISELLEDARE Alwaysuglierthanwell-wri TTENLETTERSPOORLYCUT/SINCE ADEFECTINTHEMEANSISLESSDA/ MAGINGTHANADEFECTINTHE MENTALPATTERN/ FATHER CATICH

Jovica Veljovic 'But in the Art of Calligraphy . . .' Original size 44×32.5 cm $(17 \times 12\frac{1}{2}$ in).

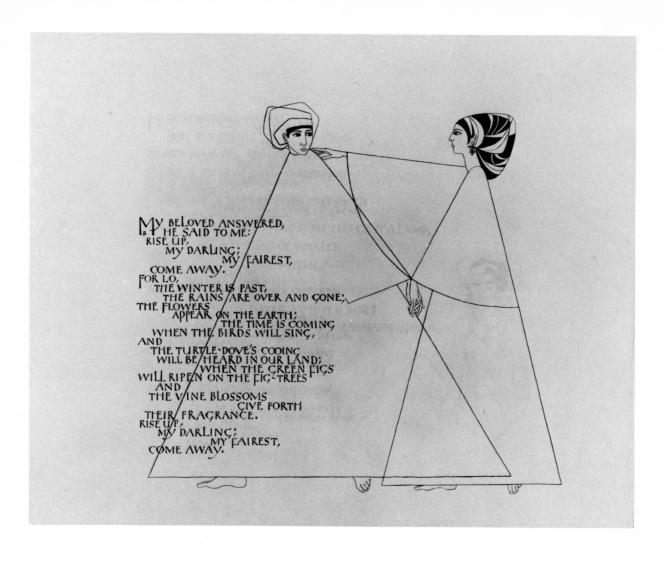

Alison Urwick

Extract from *The Song of Songs*. Written out in Chinese ink and watercolour with brush on hand-made paper. Original size 29.8×23.4 cm $(11\frac{3}{4} \times 9\frac{1}{4}$ in).

David WilliamsAlphabet. Actual size.

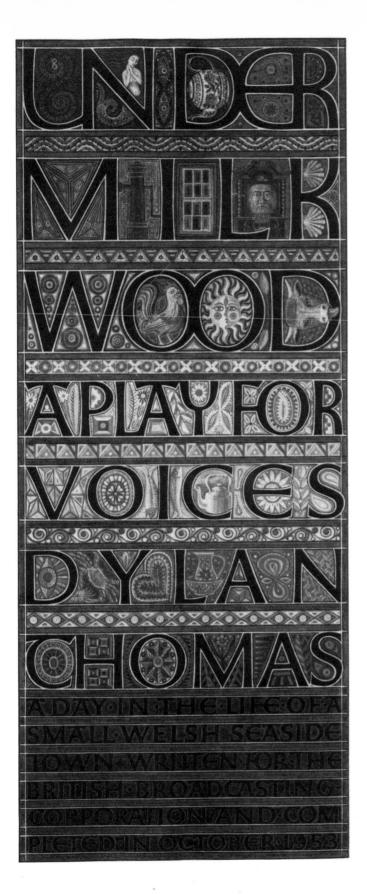

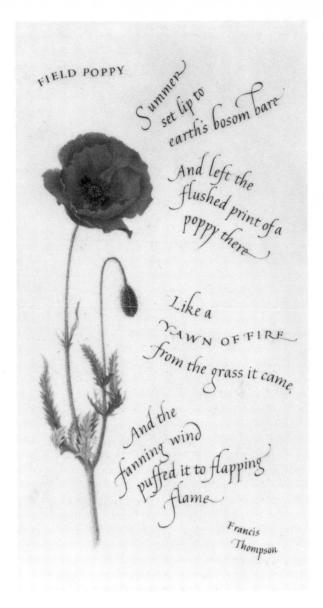

Sheila Waters

Left: Title page lettering of Under Milk Wood by Dylan Thomas. Manuscript book commissioned by Edward Hornby Esq. Original size of lettering panel illustrated here 27.3 \times 11.4 cm (10 3_4 \times 4 1_2 in). Overall page size 37.8 \times 25.4 cm (14 1_2 \times 10 in).

Above: Field Poppy. Original size 17×9.3 cm $(6\frac{5}{8} \times 3\frac{5}{8}$ in).

Overleaf: Two pages from a manuscript book of Under Milk Wood by Dylan Thomas. Commissioned by Edward Hornby Esq. Original page size $37.8 \times 25.4 \text{ cm } (14\frac{1}{2} \times 10 \text{ in}).$

the roof of Handel Yilla see the Women's Welfare hoofing, bloomered, in the moon.

At the searend of town, Mrand Mrs Floyd, the cocklers, are sleeping as quiet as death side by wrinkled side, toothless, salt and brown, like two old kippers in a box.

And high above, in Salt Lake Farm, Mr Utah Watkins counts, all night, the wife-faced sheep as they leap the fences on the hill. smiling and knitting and bleating just like Mrs Utah Watkins.

Yawning Thirty-four, thirty-five, thirty-six, forty-eight, UTAh WATKINS eighty-nine...

Bleating Knit one slip one

Knit two together

Pass the slipstitch over...

MRS UTAh WATKINS

Ocky Milkman, drowned asleep in Cockle FIRST VOICE Street, is emptying his churns into the Dewi River,

Whispering

regardless of expense. OCKY MILKMAN
and weeping like a funeral. FIRST VOICE
Cherry Owen, next door, lifts a tankard to SECOND VOICE
his lips but nothing flows out of it. He shakes
the tankard. It turns into a fish. He drinks
the fish.

P.C.Attila Rees lumps out of bed, dead to 'FIRST VOICE the dark and still foghorning, and drags out his helmet from under the bed; but deep

1

Softly WHAT seas did you see EPROBERT Tom Cat, Tom Cat, In your sailoring days Long long ago? What sea beasts were In the wavery green When you were my m CAPTAIN CAT I'll tell you the truth. Seas barking like seals, Blue seas and green, Seas covered with eels And mermen and whales ROSIE PROBERT What seas did you sail Old whaler when On the blubbery waves Between Frisco and Wales You were my bosun? Astrue as I'm here CAPTAIN CAT Dear you Tom Cat's tart You landlubber Rosie You cosy love Му егву ав егву My true sweetheart, Seas green as a bean Seas gliding with swans In the seal-barking moon

67

Peter Halliday

Vision and Prayer by Dylan Thomas from The Poems published by J M Dent & Sons Ltd and New Directions Inc. (Reproduced by permission of the Trustees of the late Dylan Thomas.) Original size $55.8 \times 22.8 \text{ cm} (21\frac{3}{4} \times 8\frac{7}{8} \text{ in})$.

Facing page

Charles Pearce

Declaration of Independence. Manuscript book in a private collection. Written out and decorated in gold and silver leaf and gouache with pens and brushes on handmade paper. Original size 43×58.4 cm (17 \times 23 in).

Facing page

Donald Jackson

Letter patent granting the Borrowing of the Charter of Armsfield. Written out in Chinese stick ink, gesso ammoniac and powdered gilding with quills and brush. Original size 41.9×55.8 cm $(16\frac{1}{2} \times 22$ in). Courtesy, Lord Chartris of Armsfield.

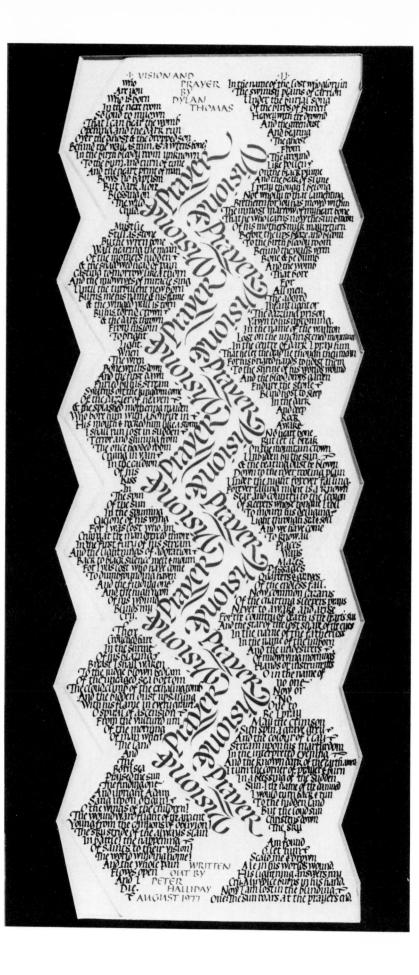

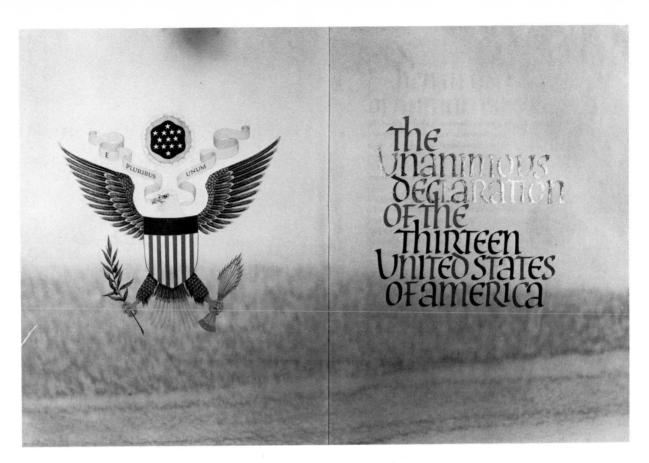

Frencher for a common his figure the second of the second and the second med the second secon

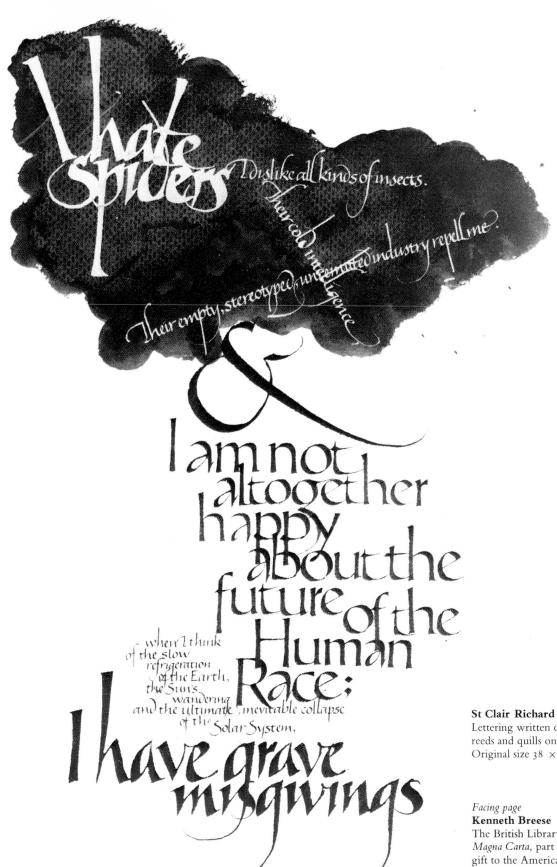

Lettering written out in Sumi ink with reeds and quills on hand-made paper. Original size 38×30.4 cm (15 \times 12 in).

The British Library Translation of the Magna Carta, part of the Bicentennial gift to the American People. Final version etched out and gilded on clear glass. Original size 41.8×24.2 cm (19 \times 11 in).

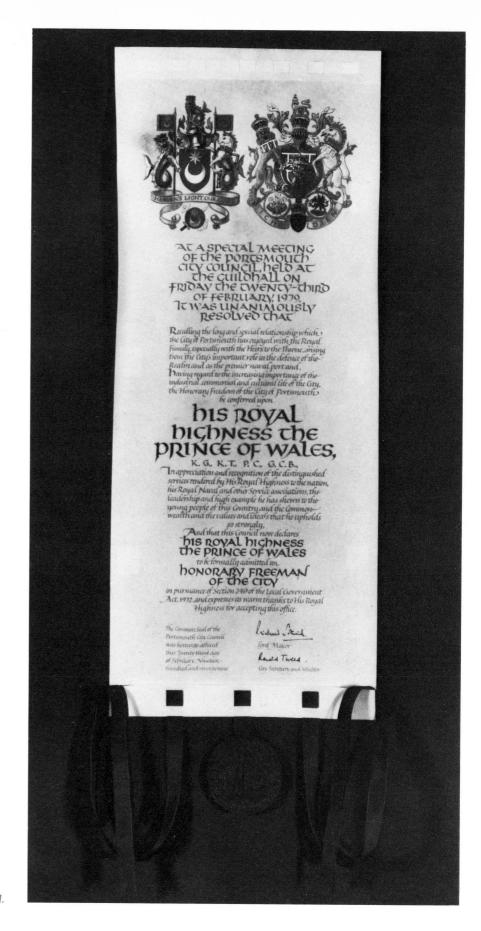

David Graham

Freedom Scroll presented by the City of Portsmouth to HRH the Prince of Wales. Main text in blue. Decorated with raised and flat gold. Surface: Vellum. Original size 58×23.5 cm $(22\frac{1}{2} \times 9$ in). By gracious permission of HRH the Prince of Wales and courtesy of Portsmouth City Council.

The Work which which which thou doest. The witten out by Dia Finnin 1977

Donald Jackson

Presentation certificate written out in black stick ink and powder gold with quill pen on vellum. Original size $19 \times 40.6 \text{ cm} (7\frac{1}{2} \times 16 \text{ in})$.

Ina Saltz

Quotation from the book of *Deuteronomy*. Written out in gouache with Mitchell nibs on Canson paper. Original size 38.7×32.3 cm $(15\frac{1}{4} \times 12\frac{3}{4}$ in).

New York City Ballet

John E Benson

Brush lettering. Brush and ink on Japanese paper. Width of original 23.7 cm (94 in).

Linda Christensen

Lettering written out in frisket, watercolour wash and gouache on watercolour paper with Speedball nibs. Ay and watiles made nine bean to the lay be and live alone in a be floud of and is hall have some peace the peace the layer and is hall have some peace the layer and is the layer and some perfection.

Innisfree Byzantium: Nature arts the layer and some perfection is the layer and some perfection in the layer and some perfection is the layer and wattles may like there of clay and wattles may like bean rows will have there a

As if you could kill time without injuring eternity. Thoreau

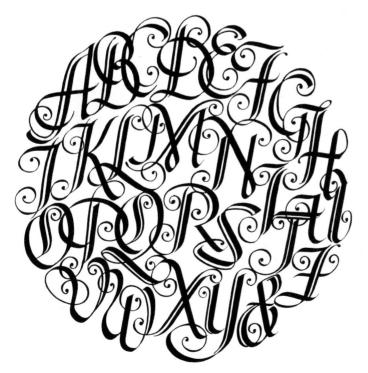

Paul Shaw

Quotation from Thoreau. Original size 28×21.5 cm (11 $\times 8\frac{3}{8}$ in).

Joan Pilsbury

Record of Arms of the Prime Wardens of The Fishmonger's Company, Volume I. Full colour and gold on vellum. Original size 31.7×24 cm $(12\frac{1}{2} \times 9\frac{1}{2}$ in).

Vera Ibbett

Alphabet design. Diameter of original 16.8 cm (6 in).

William Metzig Quotation from Malcolm X. Written out in inks on paper. Original size 36.8×26 cm $(14\frac{1}{2} \times 10\frac{1}{4} \text{ in})$.

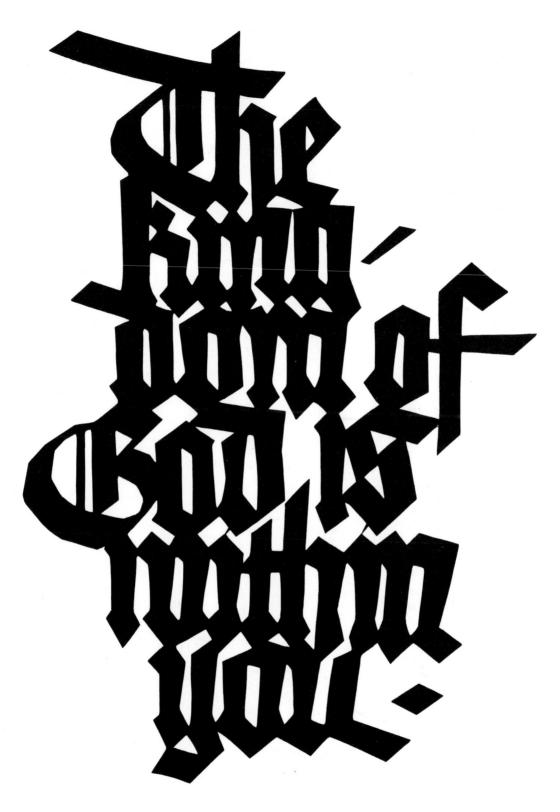

Guillermo Rodriguez-Benitez Letters cut from a heavy black paper and mounted on white paper. Original size $28 \times 19 \text{ cm } (11 \times 7\frac{1}{2} \text{ in}).$

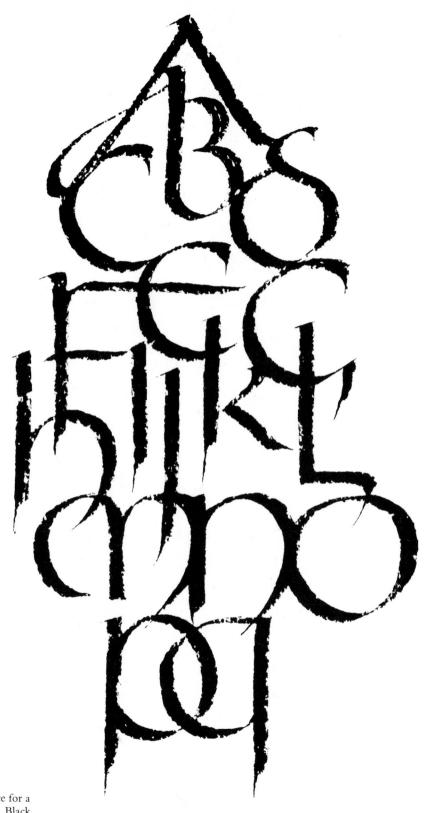

Maura Cooper Barnard 'Uncial design'. Exhibition piece for a show at the Brooklyn Museum. Black India ink on De Wint paper. Original size 33 × 20 cm (13 × 8 in).

Werner Schneider Lettering. Original size 58.5×37.5 cm $(23 \times 15$ in).

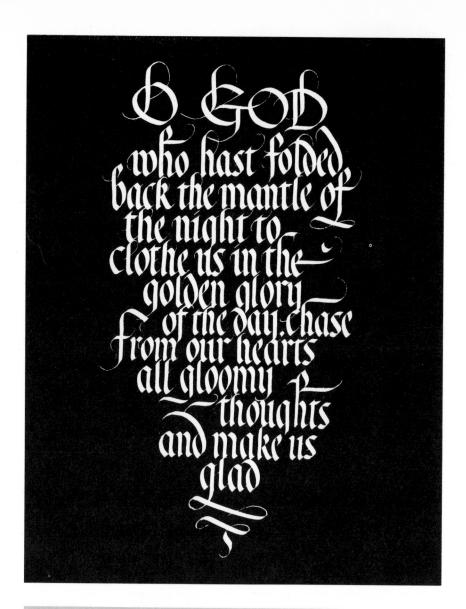

Dorothy Avery

Lettering in white gouache on black paper. Approximate size of original 54×28.6 cm (7×13 in).

Margery Raisbeck

Lettering. Original size 13.9 \times 20.2 cm ($5\frac{1}{2} \times 8$ in).

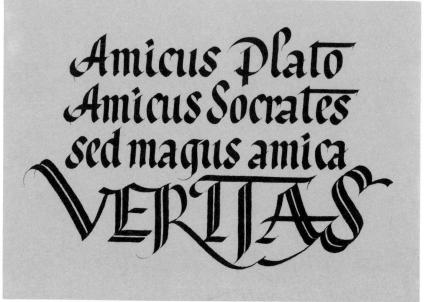

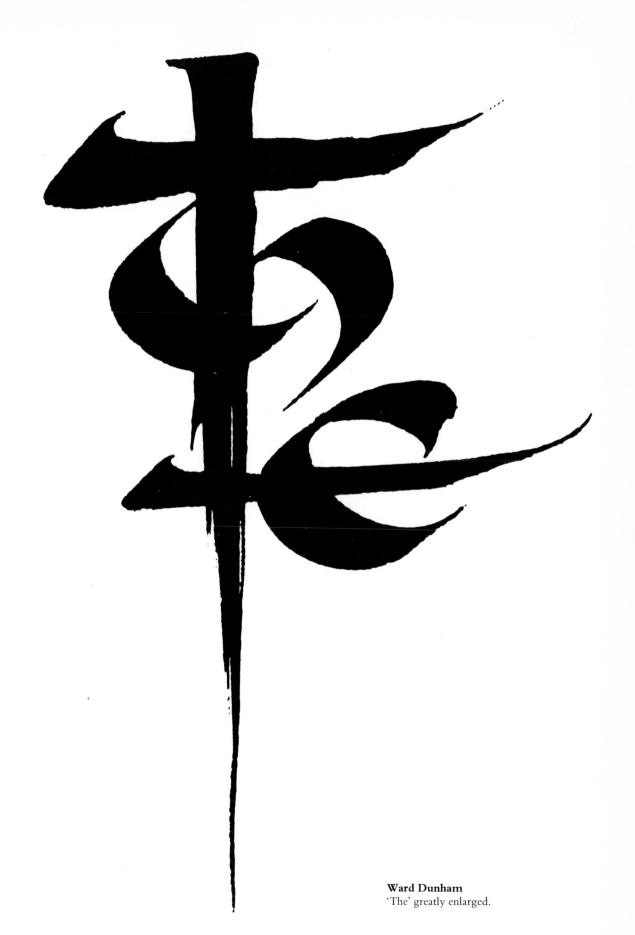

AN HOUR-GLASS A busy, bustling, still repeated dream. ON THE RUN,

Wendy Westover

Quotation from John Clare. Alternate lines in brown and white. Brush and fine pen lettering on Kraft paper. Original size 35.5×55.8 cm (14×22 in).

John Weber

Quotation from Mahatma Gandhi. Commissioned by Joyce Miller of CARE, an organization helping needy people around the world. Original size 22.8×30.4 cm $(9 \times 12$ in).

To the millions who have to gonithout two meals a day the only acceptable form in which God dare appear is food.

MAHATMA GANDHI

In order that the foresaid injurious efforts of the king of England may the more conveniently be repressed and that the said king be the more quickly compelled to withdraw from his perversand hostile incursions, the said king of Scots shall take care to begin and continue war against the king of England at his own cost and expense with all his power and with all the power of his subjects and of his kingdom, as often as it be opportune. The prelates of Scotland, as far as it be law ful to them, with the earls barons and other nobles and also the universitates ac communitates villarum of the kingdom of Scotland shall make war against the said king of England in the same manner as is above expressed, with all their strength. The prelates earls barons and other nobles and also the universitates communitates que notabiles of the said kingdom of Scotland shall direct to us as soon as may be their letters patent hereon fortified with their seals. It was also agreed that if it happen the foresaid king of England to invade the kingdom of

cotland by himself or by another after war has beginn by the king of Scots at our request or after this present agreement or treaty has been entered upon between us by occasion thereof we provided we be forewarned thereof on the part of the same king of Scots within a suitable time, shall give him help by occupying the said king of England in other parts, so that he hall thus be distracted to other matters from the foresaid invasion which he has begin. If however, the foresaid king of England happens personally to leave England orgoes out of it with a notable number of infanitry or cavalry while war lasts between him and us, then especially the said king of Scotland with all his power shall take care to invade the land of England as widely or deeply as he can

George Thomson

'Treaty with France 1295'. Written out in ink and watercolour with raised gilding on hand-made paper. Original size $50 \times 37 \text{ cm } (19\frac{1}{2} \times 14\frac{3}{8} \text{ in}).$

Alice

Poster. The original is an unretouched piece for exhibition, later reproduced in the same size as a poster for a lecture series. Original size $59.6 \times 47 \text{ cm } (23\frac{1}{2} \times 18\frac{1}{2} \text{ in})$.

For a long time it had seemed to me that life was about to begin-real life. But there was always some obstacle in the way. Something to be got through first, some unfinished business; time still to be served, a debt to be paid. Then life would begin.

At last it dawned on me that these obstacles were my life.

B. HOWLAND . Calligraphy by David Mckelburg

on scribonn.

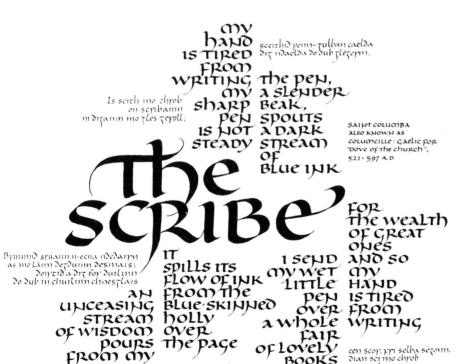

za aenach lebar lizoll

David Mekelburg

A quotation from the book *Life in the Snakepit* by Bette Howland. Written out in Chinese stick ink with an automatic pen on Strathmore Kid Finish Bristol.

Terry O'Donnell

'The Scribe'. Written out in ink and gouache with a metal and nylon pen on Saunders hand-made paper. Original size 33×45 cm (13×17 in).

Theo Varlet AN EDUCATION THROUGH BOOKS

is a companion which no misfortune can depress - no crime destroy no enemy alienate - no despotism enslave.)

* At home, a friend; abroad an introduction; in solitude, a solace; and in society an ornament.

Without books what is man?

Hermann Zapf

Quotation by Theo Varlet. Commissioned for The San Francisco Public Library for their collection of calligraphy.

IVAN THETERRIBLE E-IVANTHEFOOL

David Gatti

Lettering for a bookjacket. Width of original artwork 29.6 cm (11 $\frac{5}{8}$ in).

Pat Topping

Christmas greetings card. Printed size 14×14 cm $(5\frac{1}{2} \times 5\frac{1}{2}$ in).

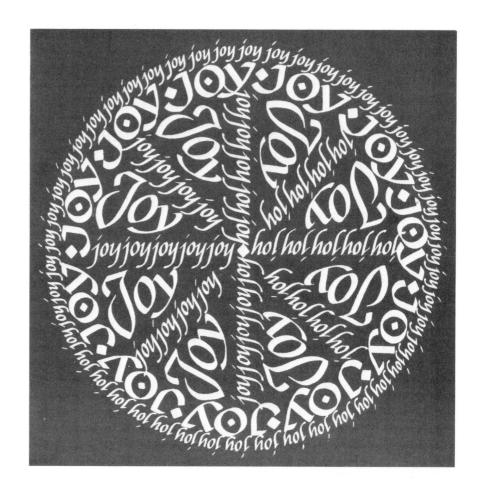

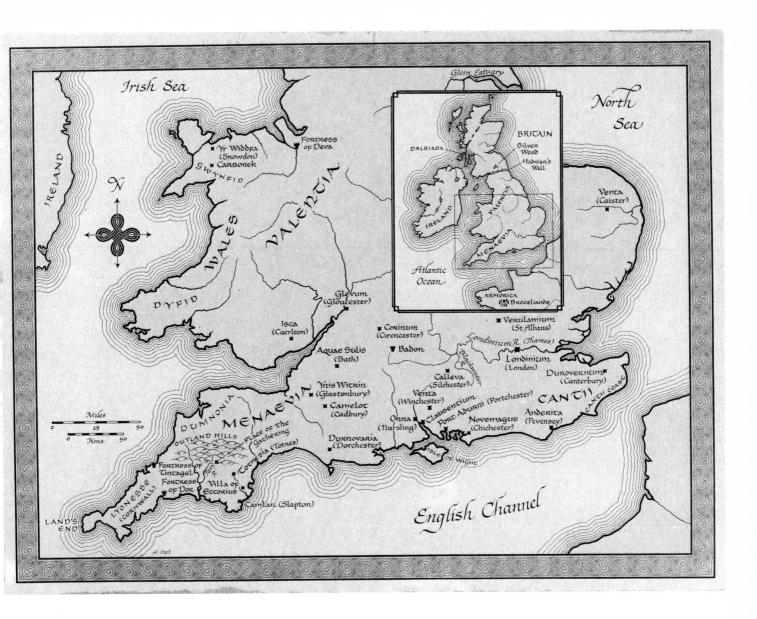

Donald K. Adams

Anita Karl

Endpapers for *The Pendragon* by Catherine Christian, published by Alfred Knopf. 1979.

David Mekelburg

Calligraphic letterheading.

David Quay Lettering for a bookjacket. Width of original artwork 25.4 cm (10 in).

David Kindersley Two bookplates. Actual printed size.

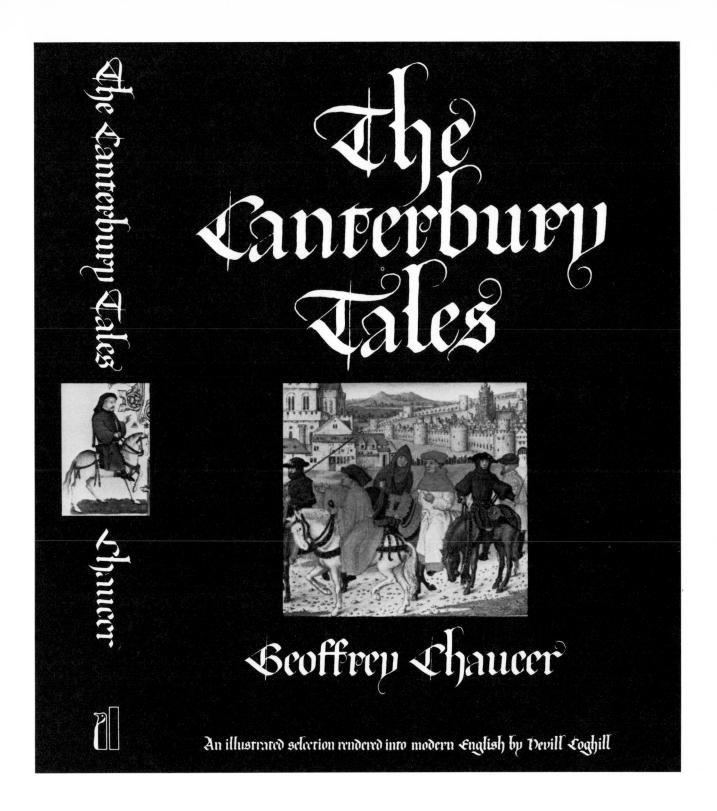

Nancy Winters

Calligraphy for *The Canterbury Tales* published in 1977 by Penguin. Shown here on the jacket but used throughout the book for titles and headings. Printed size $21 \times 19 \text{ cm } (8\frac{1}{4} \times 7\frac{1}{2} \text{ in})$.

Bo Berndal

Christmas greetings card. Original width of lettering 12.6 cm ($4\frac{7}{8}$ in).

Gerry Fleuss and Lida Lopes Cardozo Bookplate. Actual printed size.

Kenneth Breese

Handpainted symbol for the Gordon Restaurant, Scotland.

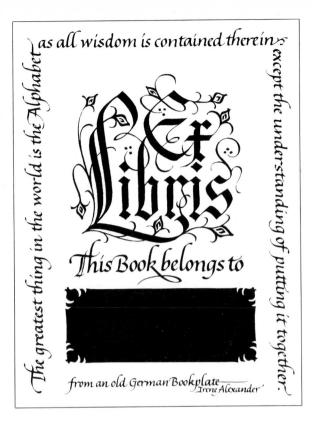

Irene Alexander

Bookplate designed for personal use and to raise money for the Society for Italic Handwriting British Columbia. Written out with William Mitchell round-hand nibs number 00, 3, 4 and 5. The name area, 'This book belongs to' and the surrounding lettering in red. All other lettering in black. Actual printed size. Original size 15.2 × 20.3 cm (6 × 8 in).

Imbertina

Muriel Nasser

Lettering for a bookjacket.

→ WIT-NEWBURGH ST-LOHDOHW!

MTCRANKS-OFF REGENT ST-TEL: 014393002

IN-HEALS-196-TOTTENHAM CONTRO

WHODON WIAIBJ-TEL: 01-636-1666

WI38 CASTLE ST-GUILDFORD SVRREY

WIGUI JUQ TELEPHONE 0483-77707

Donald Jackson

Press advertisement. Written out in stick ink with quill on layout paper. Original size 20.3 × 10 cm (8 × 4 in). Actual printed size. Courtesy of the Craftwork Gallery.

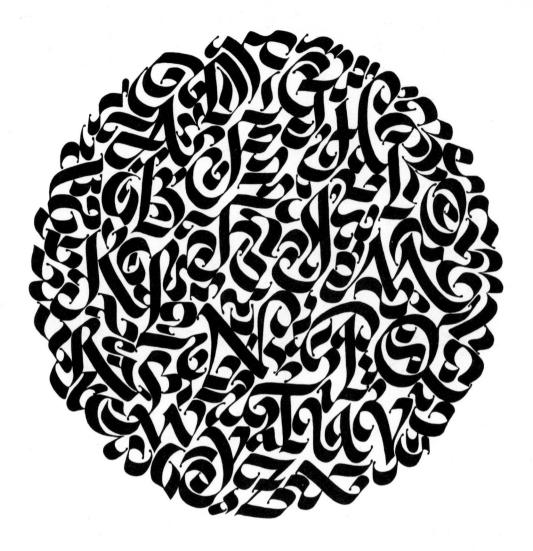

John Weber

Alphabet rosette used as a logotype on John Weber's personal stationary.
Diameter of original 51 cm (20 in).

Bo Berndal

Two bookplates. Actual printed size. Original width of lettering 'JB' 5.2 cm (2 in). Original width of oval 'Peo Kjellgren' 9 cm $(3\frac{1}{2}$ in).

DAS USAE UTEN

In meiner Heimat Lebt der Brauch:

ift verronnen der Weihe-Rauch/
liegt der Tote im Grabe/
klumpt auf den Sarg die Schollengabefo tönen auf einmal alle GlockenUnd blieb ein Seelefünklein wo hocken/
ein Atam bloß/ein Seufzer/der bang
vorm Tode in die Büsche entsprang:

die Glocken ernten alles ein/ ihr Echo betet in Dickicht und Hain/ fie beschreien den Acker/besingen den Hang mit erzenan/Munde/mit der Ewigkeit Klang!

Sie schwellen ums Haus/verjagen den Atb/ fie schlucken noch der Dinge Hauch/ fie drängen den Toten von Roß und Kalb/ zerren zuletzt ihn vom Hunde auch

Richard Billingar

Sabstbeginn

Da Fina fingt zum 21baibstamIm 21pfd bräund sich da Fan2Vipfdmüd die Zäume schweigen21chd in die 2Violan stagenSear sich an Zear hängtZur 21sta sich die Frummed brängtDar Fam aus wifar Delaume quollEin Zimlein in der Faust mir schwollIch sauge mich ins Fruchtsleich einDie 2Vange heiß vom astan 2Vein-

Xichard Villinger

Friedrich Neugebauer

Two pieces from *Der Garten Haucht* by Richard Billinger. Printed size 28.5×12.8 cm $(11\frac{1}{4} \times 5 \text{ in})$.

FOR UNTO US A CHILD IS BORN, UNTO US A SON IS GIVEN: ANO HE SHALL BE CALLED THE PRINCE OF PEACE

John Prestianni

Christmas greetings card. Actual printed size.

John Smith

Book mark. Actual printed size.

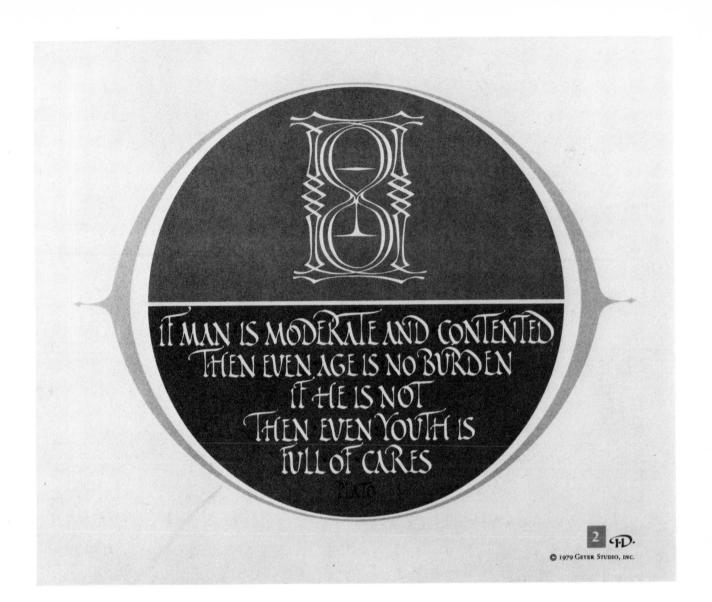

Ismar David

One of a set of seventeen style examples from the Geyer Studio writing book, *Our Calligraphic Heritage*. Printed size 18×21.6 cm $(7 \times 8\frac{7}{8}$ in).

Ieuan Rees

Letterheading. Actual printed size.

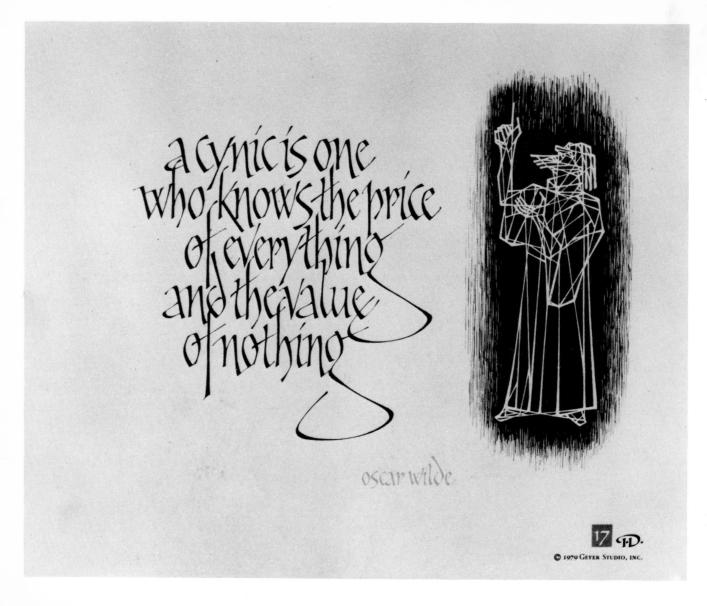

Ismar David

One of a set of seventeen style examples from the Geyer Studio writing book, Our Calligraphic Heritage. Printed size 18×21.6 cm $(7 \times 8\frac{7}{8}$ in).

Marie Angel

Left: Decorative initial from Bird, Beast and Flower. A book of poems to be published in 1980 by Chatto and Windus Limited, London.

Right: Decorative initial from Tucky the Hunter by James Dickey. Illustrated by Marie Angel, published in 1978 by Crown Publishers Inc., New York.

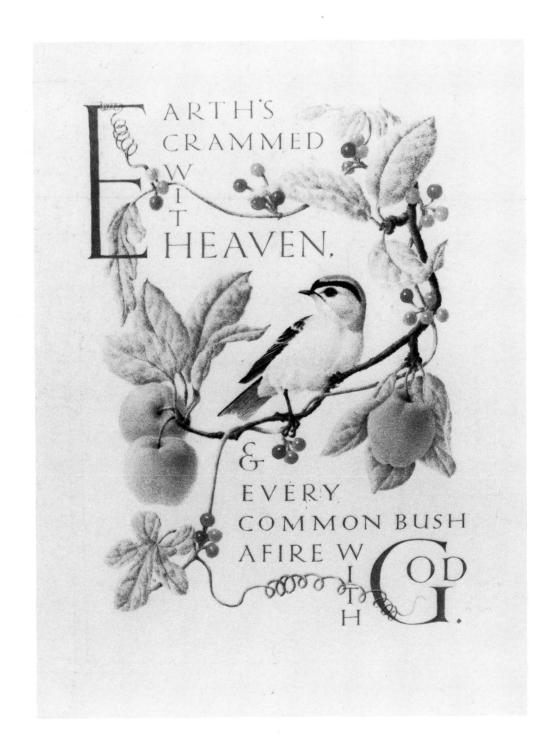

Marie Angel Quotation from *Aurora Leigh* by Elizabeth Barrett Browning. One of twelve drawings for a calendar, published in 1979 by the Green Tiger Press, La Jolla, California.

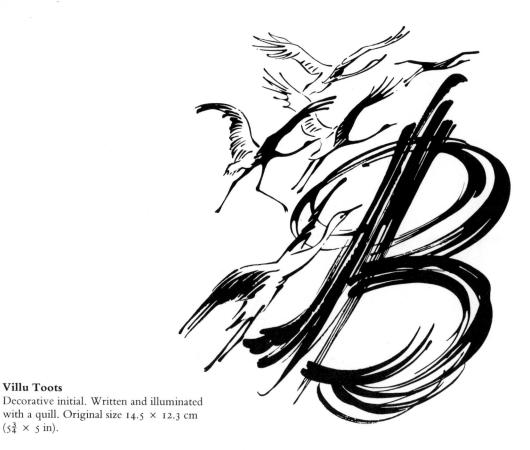

Villu Toots

 $(5\frac{3}{4} \times 5 \text{ in}).$

Villu Toots Two bookplates. Actual printed size.

iklmnop I isluwxyz abcdefyhykhnn exlibri

Michael Gullick

Front cover to *The Art of Limming* published by the Society of Scribes and Illuminators, London, 1979. Actual printed size.

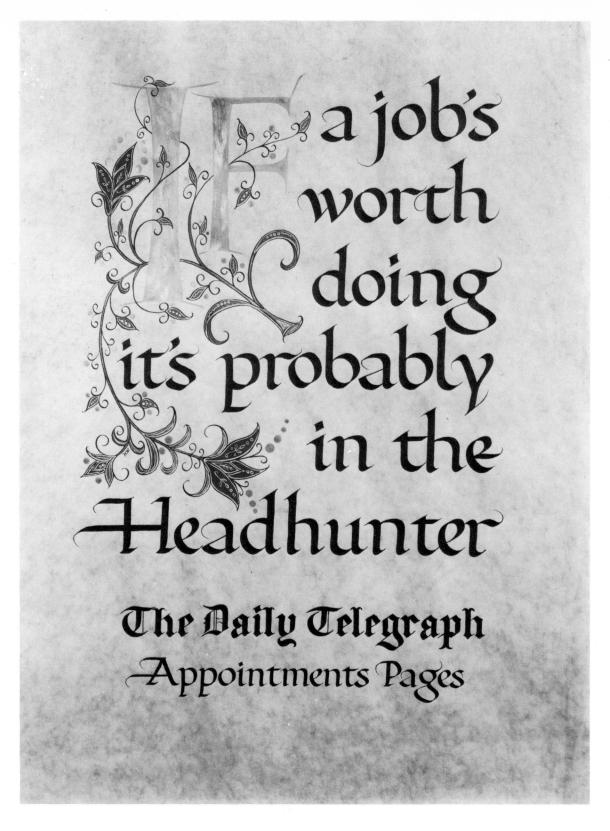

Nancy Winters

Poster for *The Daily Telegraph*. Reproduced for display on station hoardings. Printed size 152 \times 102 cm $(59\frac{1}{4} \times 39\frac{3}{4}$ in).

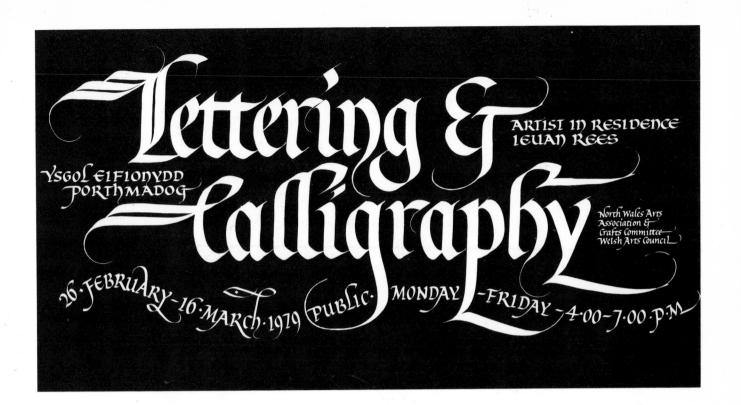

Tack Case:

Thou hast most traitorously corrupted the youth of the relm in erecting a grammar school; and whereas, before, our forefathers had no other books but the score and the tally, thou hast caused printing to be used, and, contrary to the king, his crown, and dignity, thou hast built a paper-mill).

king henry VI, Part Em. Activ. Scene VII

Ieuan Rees

Poster design. White on olive green. Printed size 21.5 \times 40.6 cm ($8\frac{1}{2}$ \times 16 in).

James Hayes

Calligraphy for the Pentalic-Taplinger Calendar 1980. Printed size 21.5 × 21.5 cm ($8\frac{1}{2}$ × $8\frac{1}{2}$ in).

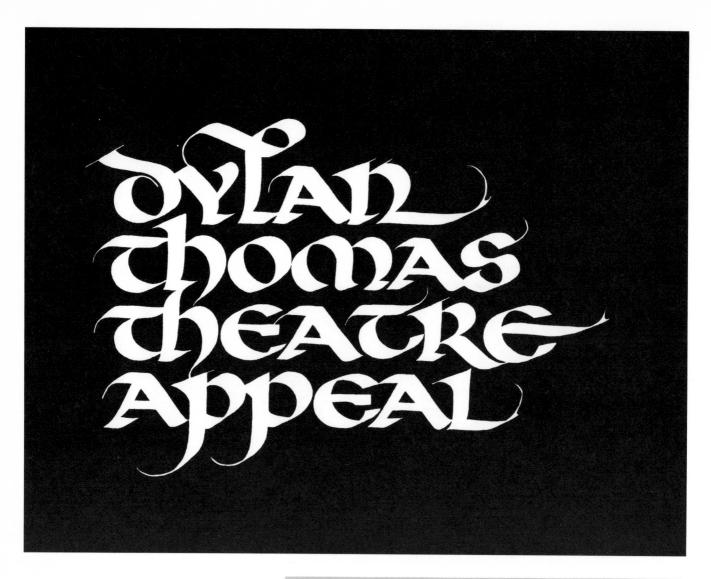

Ieuan Rees

Design for brochure and poster. Later to be incorporated in the facia of the Dylan Thomas Theatre. White letters reversed out of dark brown. Brochure size 14.7 \times 19 cm ($5\frac{7}{8} \times 7\frac{1}{2}$ in).

Peter Halliday

Christmas greetings card. Original size 16.5 \times 21 cm ($6\frac{1}{2}$ \times $8\frac{1}{4}$ in). Printed size 8.2 \times 10.4 cm ($3\frac{1}{4}$ \times $4\frac{1}{2}$ in).

the society of scribes and Illuminators requests the honour of your attendance at a lecture illustrated with slides on

: The Book of Kells :

by the most reverend G.O. simms Archbishop of Armagh on tuesday 27th March 1979 at 6.30pm-dooks open 6.15-in the Lecture theatre. The Victoria & Albert Museum Cromwell road London SW7

The Chair will be taken by MR-leuan Rees R.s.v.p MRS-S-Cavendish-hon Secretary, 54 Boileau Road London SW13 9BL

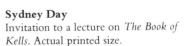

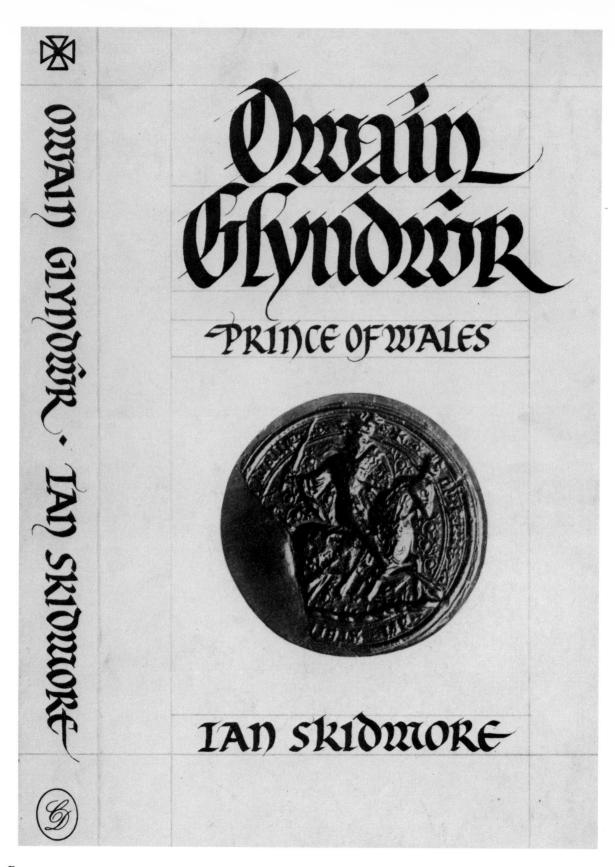

Ieuan Rees

Lettering for a bookjacket. Actual printed size

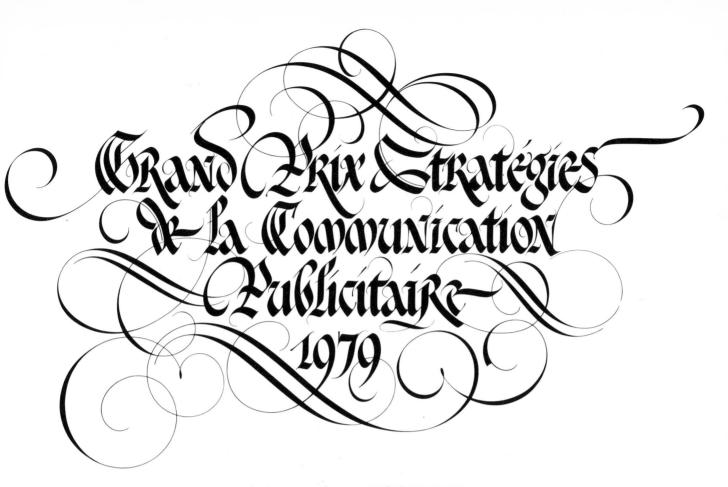

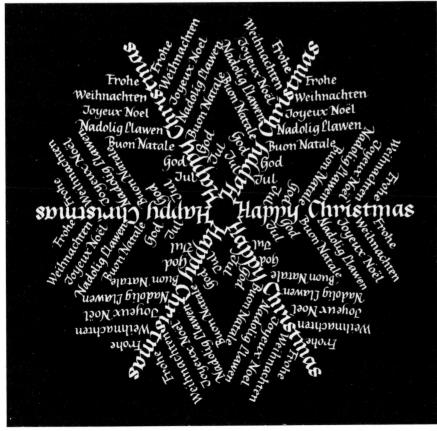

Claude Mediavilla

Calligraphy for a diploma. Original size $30 \times 42 \text{ cm } (12 \times 16\frac{3}{4} \text{ in}).$

John Smith

Christmas greetings card. Actual printed

David Mekelburg Calligraphy Drawings Serigraphs 11 March - 8 April 1978

Alphabets and names make games and everybody has a name and

all the same they have in a way to have a birthday. The thing to

do is to think of names... And you have to think of alphabets too,

without an alphabet well without names where are you and birthdays

favorable too, otherwise who are you. Everything begins with A.

GERTRUDE STEIN

India Ink Gallery

1231 Fourth Street · Santa Monica, California 90401 · (213) 393-2392

@ 1978 INDIA INK GALLERY, ALL RIGHTS RESERVED

PRINTED IN USA

David Mekelburg

Exhibition poster printed in three colours. Original written out on bond paper with Automatic and Brause pens. Original and printed size 60.9 × 45.7 cm (24 × 18 in).

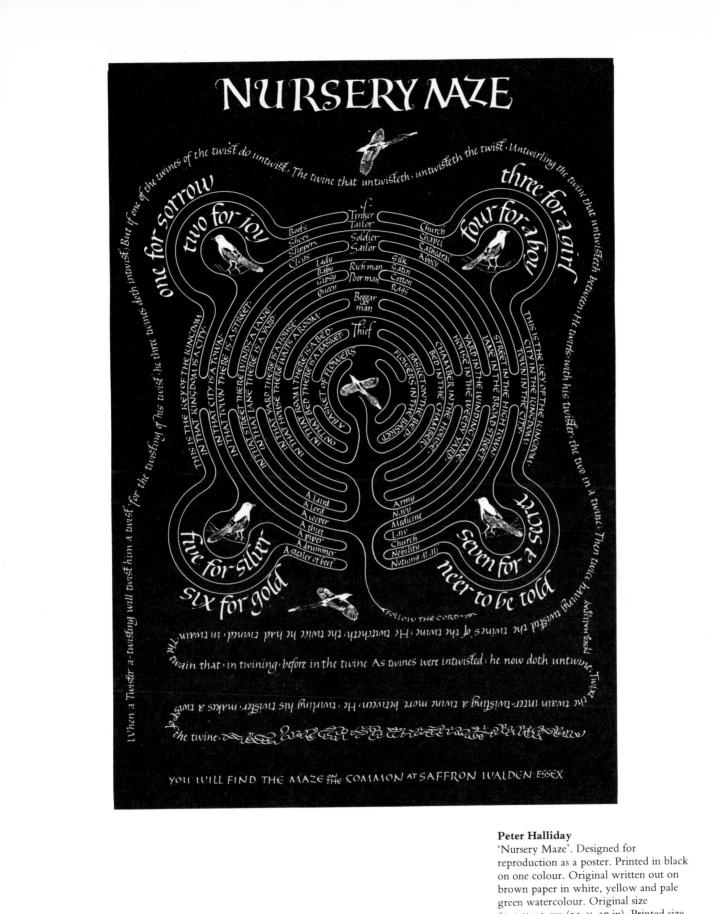

brown paper in white, yellow and pale green watercolour. Original size 63.5×43 cm (25 \times 17 in). Printed size $44.4 \times 31.7 \text{ cm } (17\frac{1}{2} \times 12\frac{1}{2} \text{ in}).$

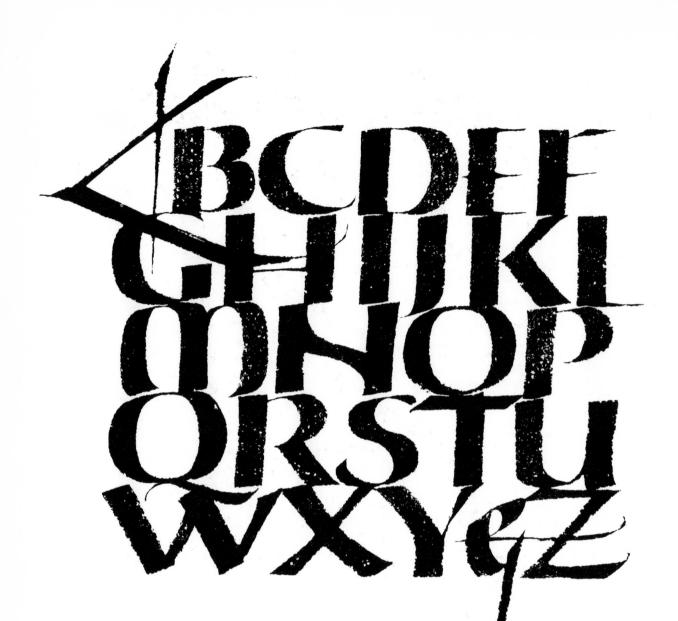

Letters are the key to our culture, they can also be a picklock to our heart. BROR ZACHRISSON

Jacqueline Sakwa Quotation from Hermann Zapf's Manmade Typographicum by Bror Zachrisson, 1954. Written out in dark green gouache on Bodleian hand-made paper. Original size 21.5×17.7 cm $(8\frac{1}{2} \times 7$ in).

Donald Jackson

Christmas poster. Written out in black stick ink with brush, quill and steel pen on layout paper. Illustrations drawn by Kate Jackson. Height of original 36.7 cm (15 in).

Press advertisement. Written out in stick ink with quill on layout paper. Drawing by Kate and Morgan Jackson. Actual printed size.

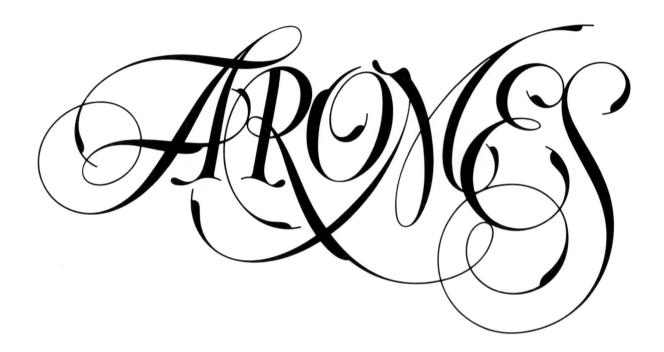

Jean Larcher

Logotype for perfume packaging.

Patricia Weisberg

Cover of The Calligraphers' Engagement Calendar 1979, published by Pentalic-Taplinger, New York. Lettering in white reversed out of red. The original was done on bond paper with a Bouwsma pen and touched up for reproduction.

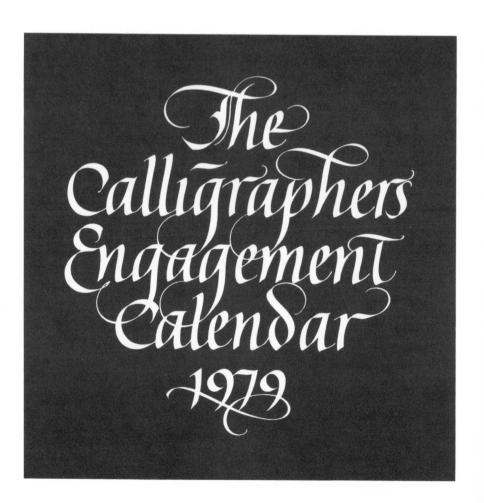

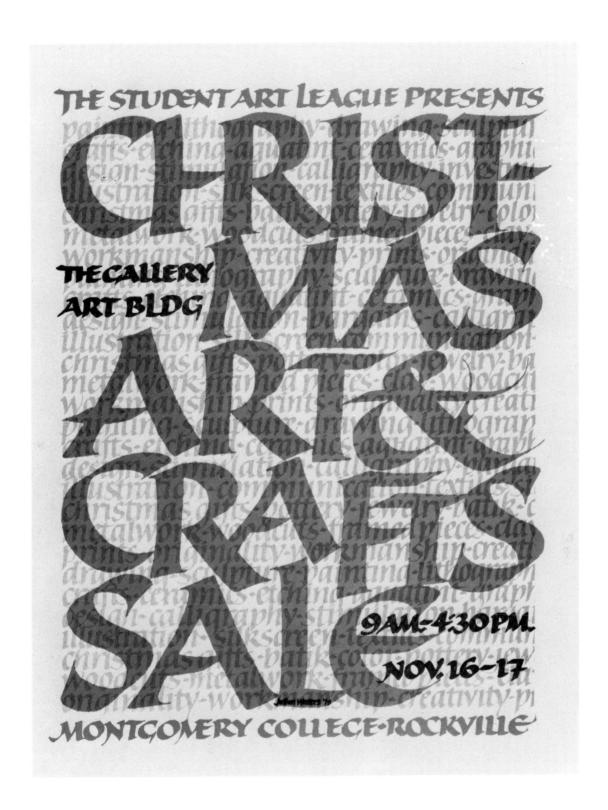

Julian Waters

Poster. Commissioned by Montgomery College, Maryland. Written out in Chinese stick ink with steel nibs and coit pen on hand-made paper. Original size 25×19 cm $(9\frac{3}{4} \times 7\frac{1}{2}$ in).

Markespeare: The Tragedy of King Richard III-11 DIS CONTENT

Julian Waters

Quotation from Shakespeare, The Tragedy of King Richard III.I.I. Written out in Chinese stick ink with semi-flexible steel broad edged pens on rough handmade paper. The large capitals were written very small then enlarged photographically to exaggerate roughness. The small capitals were written large and reduced to exaggerate smoothness. Carried out for the 1980 Calligraphers' Engagement Calendar, published by Pentalic Taplinger.

Abigail Diamond Chapman

Calligraphy for the Pentalic-Taplinger Calendar 1979. Original size 21 \times 22.8 cm (8 $\frac{1}{4}$ \times 9 in). Printed size 16.7 \times 19 cm (6 $\frac{1}{2}$ \times 7 $\frac{3}{8}$ in).

& A woman of vatour who can find? For her price is far above rubies. > The heart of her husband oveth safely trust in her, of he hath no lack of gain. A She oveth him good one over the hour good of lax, a worketh willingly with her hands: A She is like the more hands. A She bringeth her food from afar. A She riseth also while it is yet night egiveth food to her household, e. The considereth a field and a portion to her maidens buyeth it with the fruit of She girdeth her loins her hands she planteth a vineyard. with strength, a maketh strong her merchandise is good, Her lamp arms: She perceiveth that her goeth not out by night. She her hands hold the spindle? layeth her hands to the dist aff

She Stretcheth out her hand to the poor; Yea, She reacheth She is not afraid of the household are clothed with scarlet. forth her hands to the needy. snow for her household; For her She maketh for herself linen of purple I Her husband is coverlets, her clothing is fine known in the gatus; when of the land. D Sho known in the gates; when of the land. Deshe them; of delivereth them; of delivereth them; of delivereth them; of delivereth them to come. Deshe openeth her mouth with wisdom; of kindness is on her tongue. She looketh well to the ways of her household & eateth not the bread of idleness. Her children rise up & call her blessed; Her husband also, & he praiseth her:

"Many daughters have done valiently, But thou excellest them all: "UGraco
is deceitful & beauty is vain; But a woman that feareth the LORD, she shall be praised. The Give her of the fruit of her hands, whether works praise her in the gutes? Proverbs 31:10-31 אניגיל

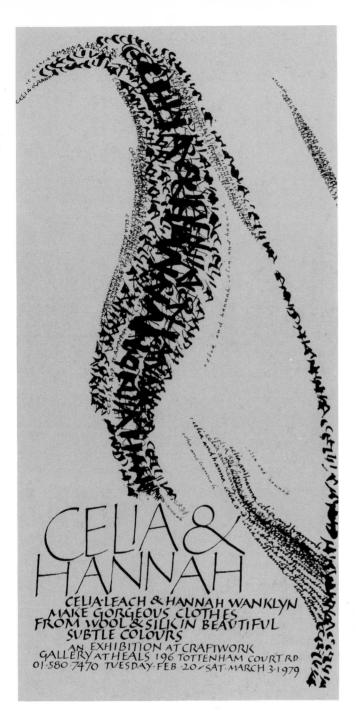

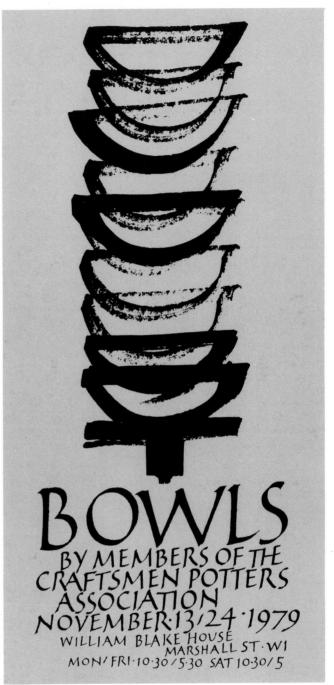

Donald Jackson

Invitation card 'Celia and Hannah'. Written out in stick ink with quill pen on layout paper. Original and printed size 21×10.4 cm $(8\frac{1}{4} \times 4\frac{1}{8}$ in).

Invitation card 'Bowls'. Written out in stick ink, felt tip pen and quills on layout paper. Original and printed size 22.2×10.4 cm $(8\frac{3}{4} \times 4\frac{1}{8}$ in).

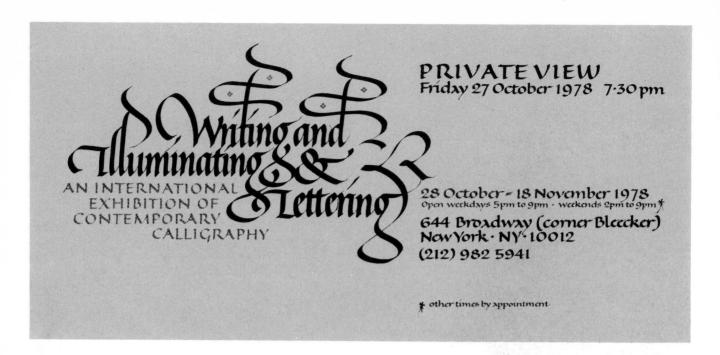

Charles Pearce

Invitation. Printed size 10.3 \times 23.2 cm (4 \times 9 $\frac{1}{8}$ in).

David Graham

Embossed menu cover for luncheon held in honour of the Royal visit to the Royal Maundy Service at Winchester Cathedral, in its 900th anniversary year. Size of menu $24 \times 19 \text{ cm } (9\frac{7}{8} \times 7\frac{3}{8} \text{ in})$. Courtesy of the Hampshire County Council.

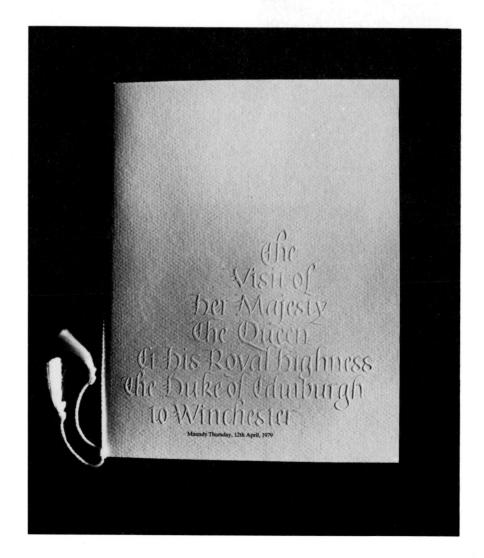

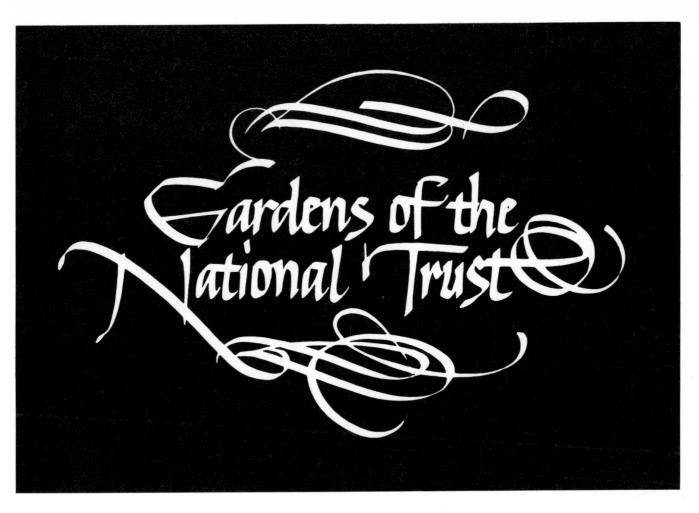

David Howells

Lettering for cover of National Trust Calendar.

Donald Jackson Emblem for use on stationary, flags and Tee-shirts.

Villu Toots
Design for a record sleeve.

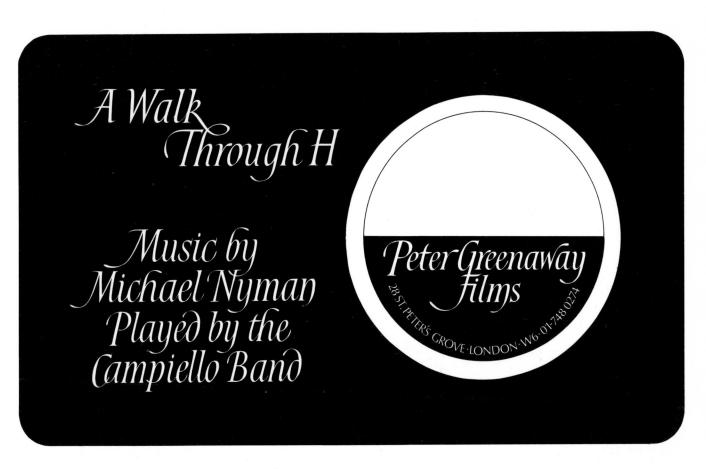

NATIONAL COMMISSION ON THE COST OF MEDICAL CARE

Kenneth Breese

Film can label and film titles in brush lettering for Peter Greenaway Films.

Brian P Clare

Logotype designed for the National Commission on the Cost of Medical Care. Original size 15 \times 26.2 cm (6 \times 10 $\frac{1}{2}$ in).

David Quay

Logotype designed for Penguin Books. Original artwork lettered to a width of 20.3 cm (8 in).

Lars Jonsson

Logotype for Swedish rail road newspaper.

Lars Jonsson

Logotype for a Stockholm gym school. Award winner in the Type Directors Club Competition, New York, 1979.

Claude Mediavilla Logotype designed for an art gallery.

Tony Di SpignaDesign for personal stationery.

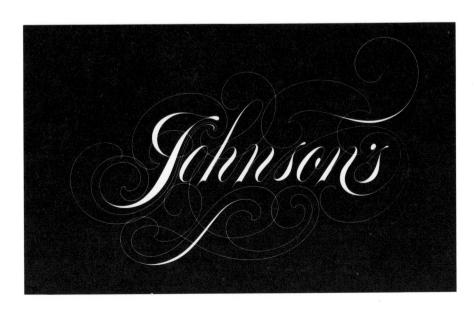

Tony Di Spigna Part of a corporate identity for Johnson's Sanitation, Minnesota.

IAM A JEW. HATH NOT A JEW EYES?

HATH NOT A JEW HANDS, ORGANS, DIMENSIONS, SENSES, AFFECTIONS, PASSIONS? FED WITH THE SAME FOOD, HURT WITH THE SAME WEAPONS, SUBJECT TO THE SAME DISEASES, HEALED BY THE SAME MEANS,

WARMED AND COOLED BY THE SAME WINTER AND SUMMER AS

A CHRISTIAN IS? IF YOU PRICK US, DO WE NOT BLEED? IF YOU TICKLE

US, DO WE NOT LAUGH? IF YOU POISON US, DO WE NOT DIE? AND IF YOU WRONG US, SHALL WE NOT REVENGE? IF WE ARE LIKE YOU IN

THE REST WILL RESEMBLE YOU THAT,

SHYLOCK . THE MERCHANT OF VENICE . ACT III SCENE I

Abigail Diamond Chapman

Calligraphy for the Pentalic-Taplinger Calendar 1979. Original size 55.8 \times 43.1 cm (22 \times 17 in). Printed size 16.7 \times 14.6 cm ($6\frac{1}{2} \times 5\frac{7}{8}$ in).

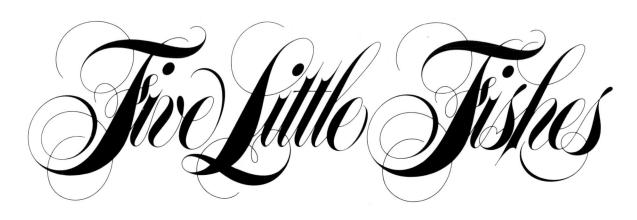

Jean Larcher

Logotype for an advertising studio in Paris, Five Little Fishes. Art director: Franck Vardon. Original drawn on scratchboard 18×61 cm $(7 \times 23\frac{3}{4}$ in).

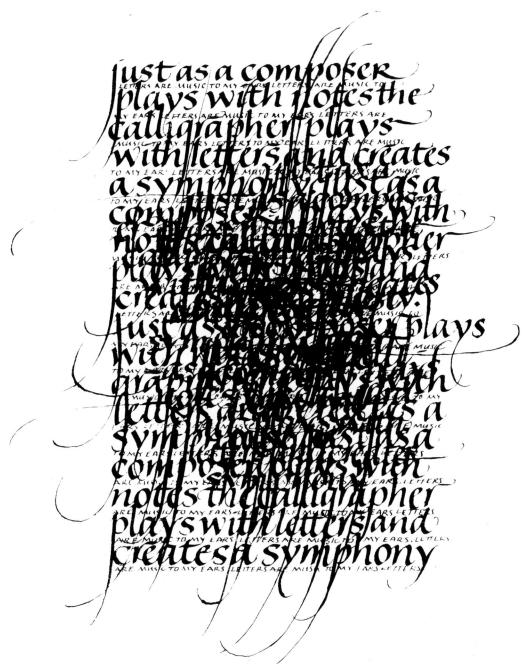

Mary Quinault Kossakowski With the theme of 'Creativity' this piece represents an attempt to recreate in letter forms the feeling of a symphony in calligraphy thus combining the visual with audio expression in the arts. Designed for The Society of Scribes 1979 Calendar. Written out in Higgins Eternal ink with two Mitchell broad-edge pens on Strathmore paper.

The poulterers' shops were still half open and the functors were radiant in their glory. There were great, round, pot belied baskets of chestnuts, shaped like the waistocats of jolly old gentlemen, lolling at the doors, and tumbling out into the street in their apopleetic opulance. There were ruddy, brown faced, broad-girthed Spanish Onions, shining in the fatness of their growth like Spanish Briars, and winking from their shelves in wanton styness at the girls as they went by, and glanced demurely at the hung up mistletoe. There were pears and apples at the hung up mistletoe. There were pears are apples at grapes, made, in the Shopkupers benevolence, to dangle from conspicuous hooks, that people's mouths might water gratis as they passed.

Eharles Dickens H. Ehristmas Earol

Eleanor Winters

Christmas greetings card. Illustration by Linda Dannhauser.

Patricia Weisberg

Calligraphy for the Pentalic-Taplinger Calendar 1979.

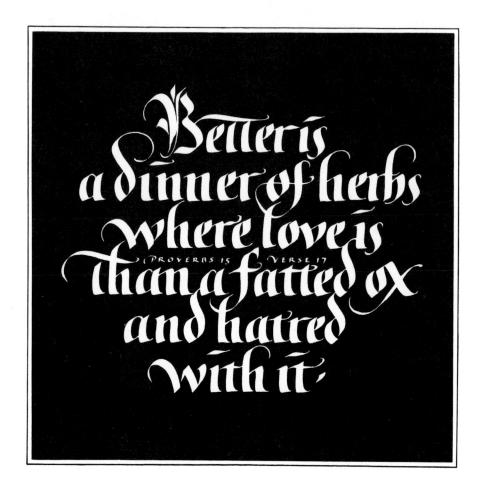

Raphael Boguslav Exhibition poster. Printed size 35.5 × 28 cm (14 × 11 in).

MANN MERS DESTINATION OF THE PROPERTY OF THE

In came a fiddler with a music book; and went up to the lofty desk, and made an orchestra of it, and tuned like fifty stomach-aches. In came Mrs. Fezziwiz one vast substantial smile. In came the three Miss Fezziwizs, beaming and lovable. In came the six young followers whose hearts they broke. In came all the young mense women employed in the business. In came the house-maid, with her cousin, the haker. In came the boy from over the way, who was suspected of not having board enough from his master; trying to hide himself behind the girl from next door but one, who was proved to have hadher ears pulled by her mistress. In they all came, one after another; some shull, some boldly, some

Such a bustle ensued that you might have theught a coose the garest of all birds, a feathered phenomenon to which a beack swam was a matter of course—and in truth it was something very like it in that house. Asks catchit made the space and beforehand in a little space and hissing hot. Asster Peter mashed he potations with incredible viewer. Miss Pelinga sweetened up the apple-space; Martha dusted the hot plates; Bob took tiny tim beside him in a tiny corner at the table; the two young catchits set chairs for every hoody not foreiting themselves, and mounting themselves are mouths.

David Howells and G Percival

Christmas greetings card printed in gold, blue and red. Illustrated here are both sides of card. Printed size 10 \times 21.8 cm (4 \times 8 $\frac{1}{4}$ in).

Inscriptional lettering

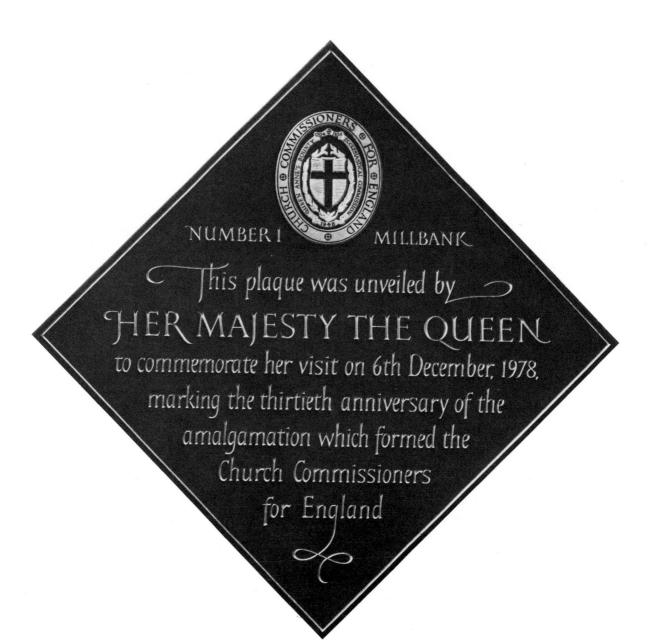

David Dewey

Commemorative plaque. Blue grey slate. 45.7×45.7 cm (18 \times 18 in).

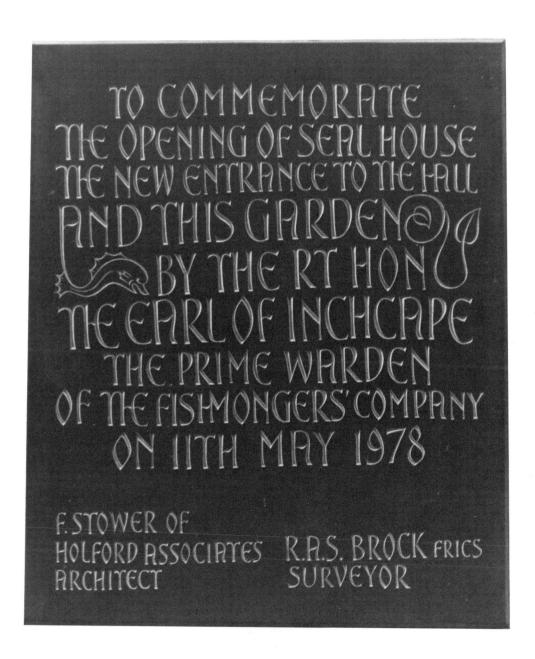

Richard Kindersley

Commemorative plaque commissioned by The Fishmonger's Company. Carved Welsh slate. $58 \times 46 \text{ cm} (22\frac{1}{2} \times 18 \text{ in})$

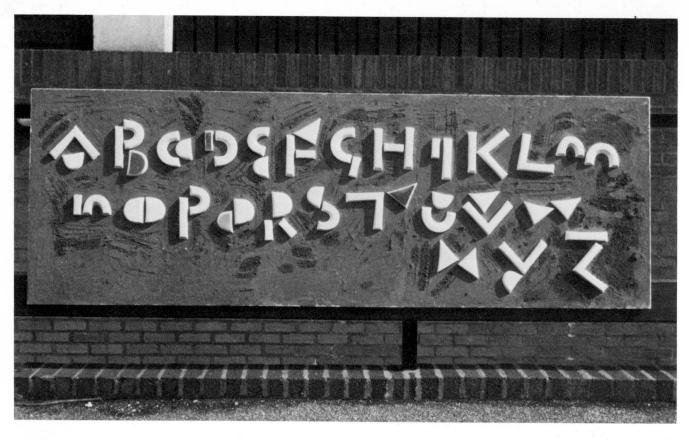

David Howells

Modular alphabet. Slip-cast ceramic units glazed and fixed to a wooden board with sand-textured surface. 76 cm \times 2.1 m (2 ft 6 in \times 7 ft).

Richard Kindersley

Commemorative plaque commissioned by the Manchester Hospital Board. Carved Welsh slate. Diameter 66 cm $(25\frac{3}{4} \text{ in})$.

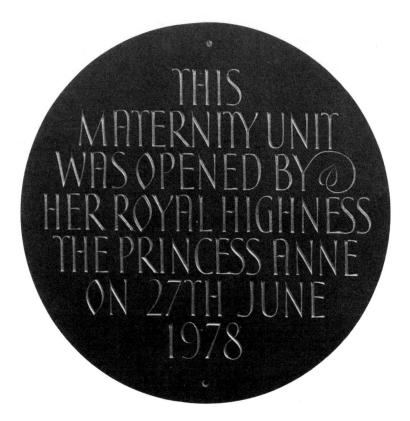

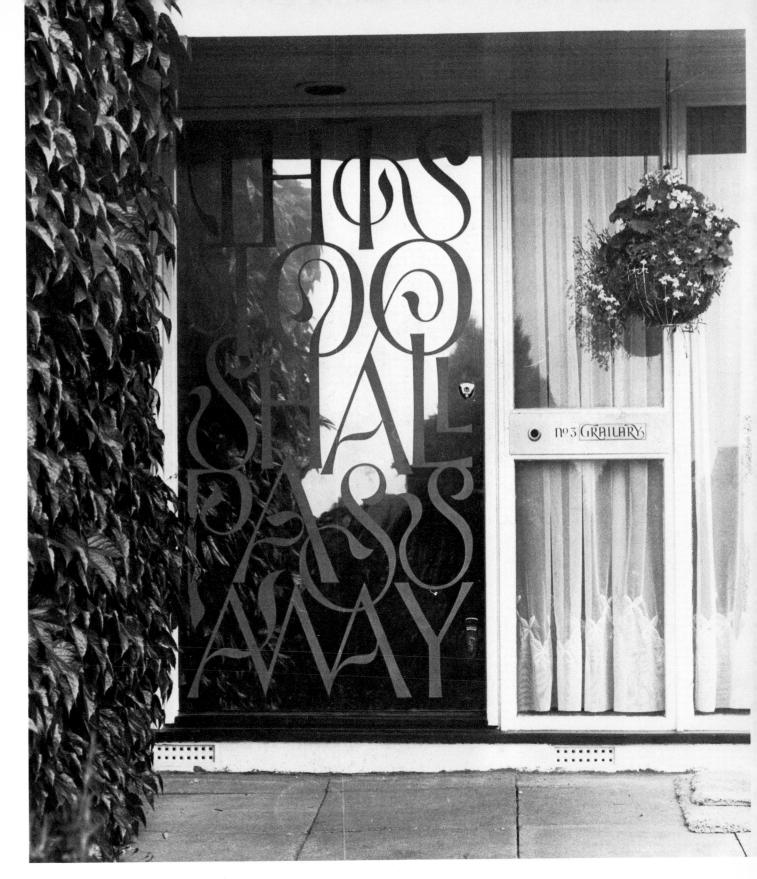

Richard Kindersley Sand blast stainless steel door.

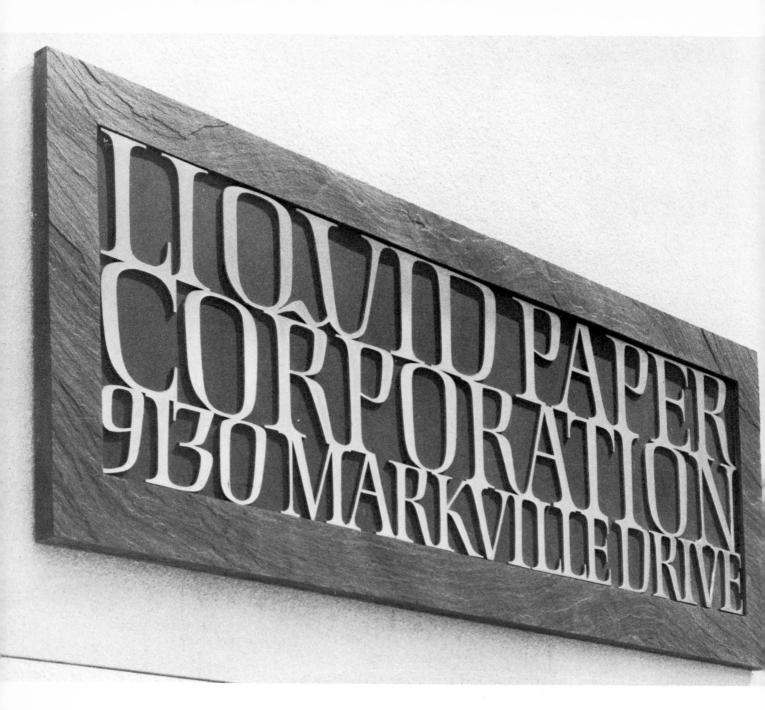

John Skelton
Sign for the Liquid Paper Corporation,
Dallas, Texas. Riven Buckingham slate.
Brass letters with chrome satin finish.
Length 3.2 m (10 ft 6 in).

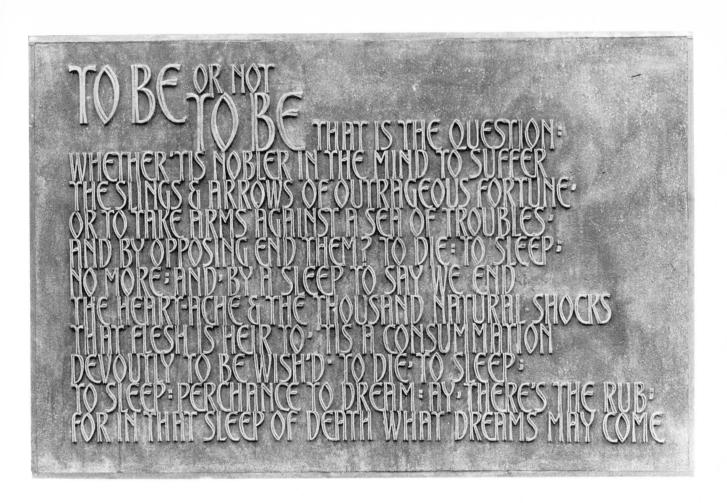

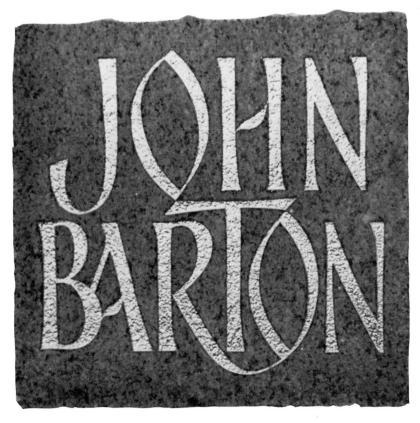

Richard Kindersley Raised lettering in plaster, stained yellow ochre. 1.3 \times 2 m (40 \times 78 in).

Sand blast granite, gilded. 30 cm sq $(11\frac{3}{4} \text{ in sq})$.

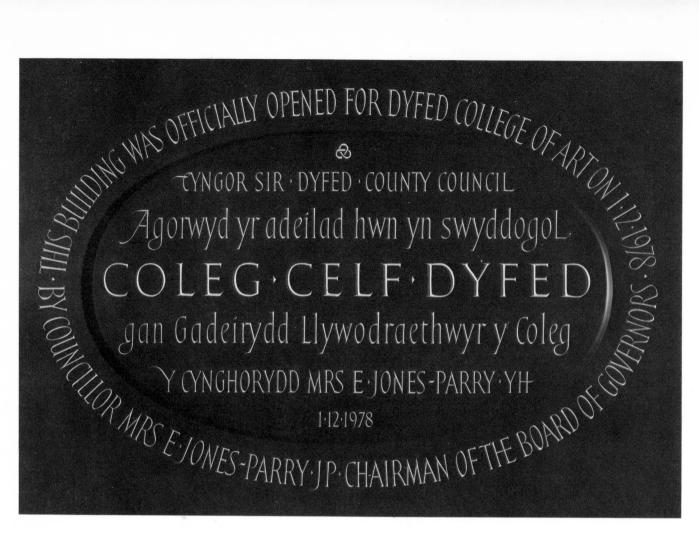

Ieuan Rees

Commemorative plaque for Dyfed College of Art, Carmarthen. Welsh slate with sunken oval.

Donald Jackson

Sign of window commissioned by Cranks Health Foods. Brush painted in signwriter's enamel. Breadth 61 cm (24 in). Courtesy Cranks Health Foods.

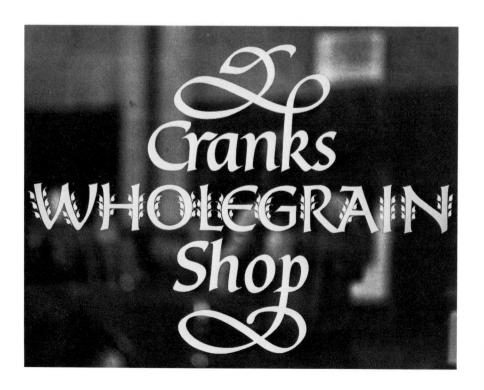

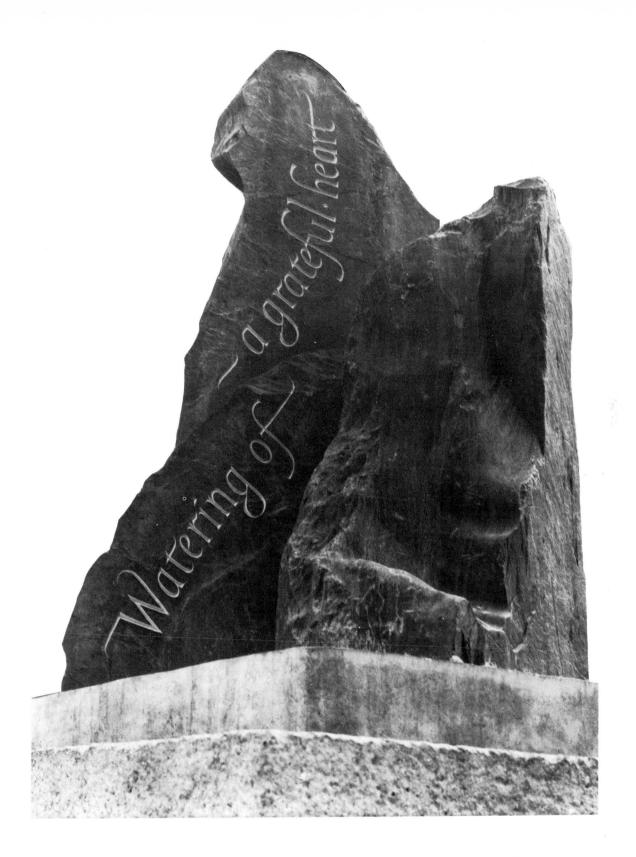

Ieuan Rees

Inscription on two boulders from Penrhyn Quarry, North Wales. Presented to the Borough of Brent, London. Height of tallest boulder approximately 2.4 m (8 ft).

LORD THOMSON OF FLEET 1894-1976

He gave a new direction to the British newspaper industry. A strange and adventurous man from nowhere, ennobled by the great virtues of courage and integrity and faithfulness

David Kindersley

Commemorative plaque. Welsh slate, cut by Kevin Cribb. 99×66 cm $(39 \times 26$ in).

Nicolete Gray

Raised letters. Portland stone.

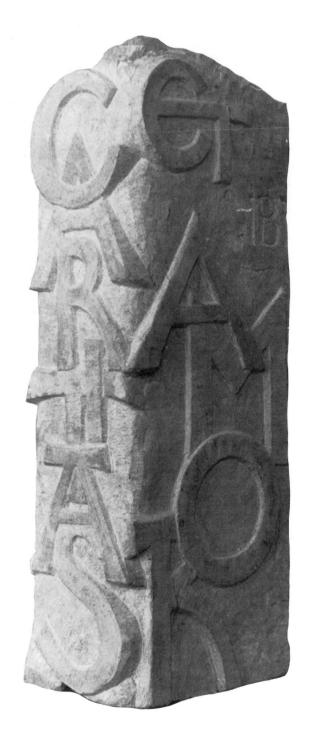

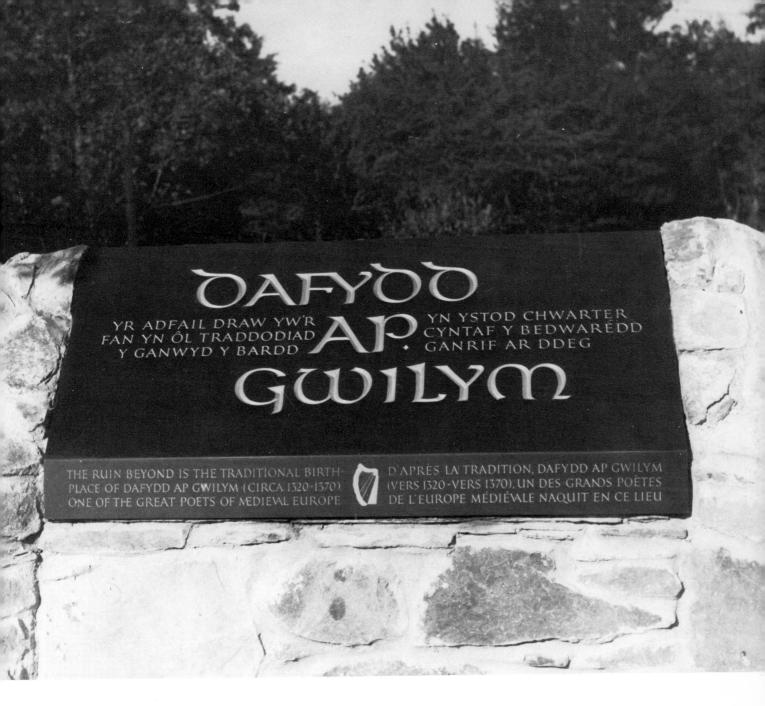

Ieuan Rees

Inscription in Welsh, English and French. Welsh blue slate. 88.8×127 cm (1 ft 11 in \times 4 ft 2 in).

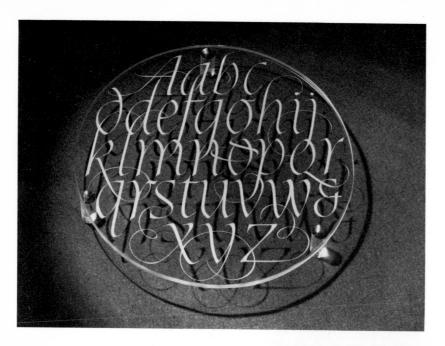

Lida Lopes Cardozo Engraved glass roundel. Exhibition piece.

Engraved glass decanter commissioned as a wedding present for Mr and Mrs David Jenkins of Oxford. Approximate height 22.8 cm (9 in).

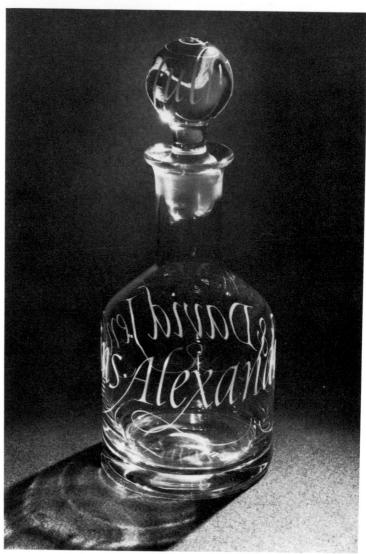

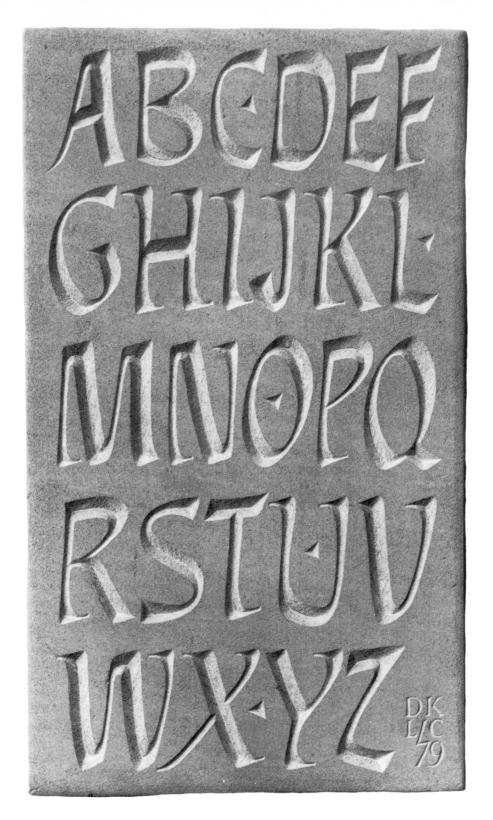

David Kindersley

Rustic Roman letters. Kelton stone, cut by Lida Lopes Cardozo. 71 × 30.4 cm (28 × 20 in).

Tentoonstelling

David Kindersley

'Tentoonstelling'. Mansfield limestone, cut by Kevin Cribb. Approximately 15.2×66 cm $(6 \times 26$ in).

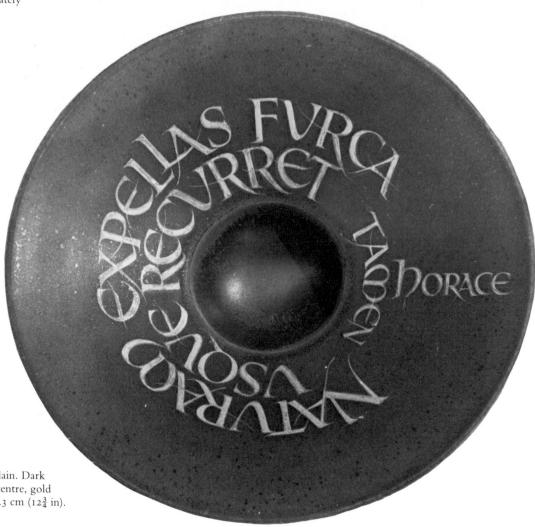

Mary White

Wide flanged bowl in porcelain. Dark green crystally glaze, black centre, gold lustre lettering. Diameter 32.3 cm (12\frac{3}{4} in).

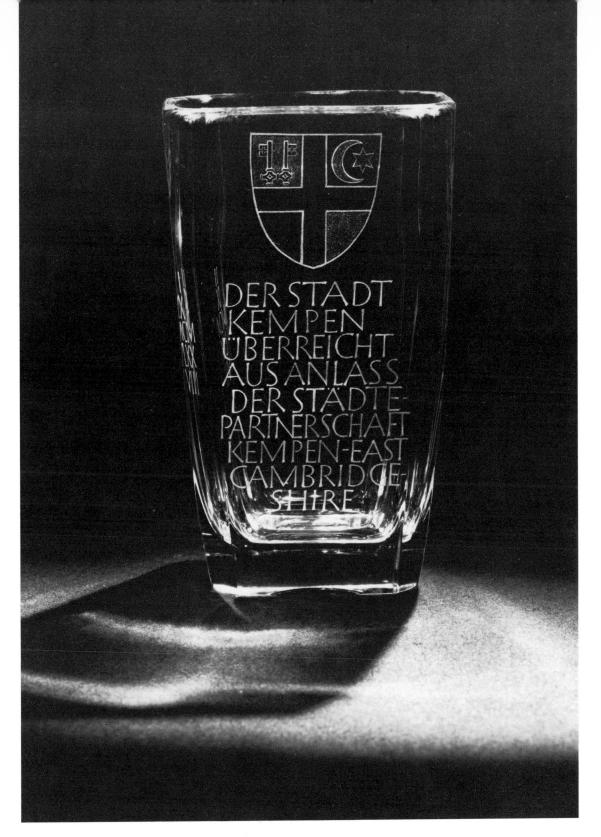

David Peace

Vase engraved in 1978 to mark the twinning of the two local authorities, East Cambridgeshire District Council and Kempen, West Germany. Commissioned by East Cambridge District Council. Height 17.7 cm (7 in).

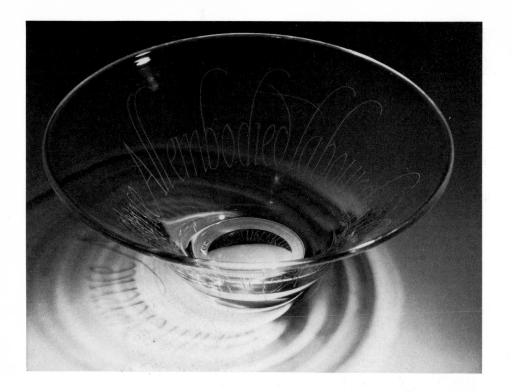

David Peace

Glass bowl engraved with the lettering 'All embodied labour should be kept in reverence'. Diameter 30.4 cm (12 in).

David Kindersley Engraved glass. Cut by Mark Bury. (26 × 18 in)

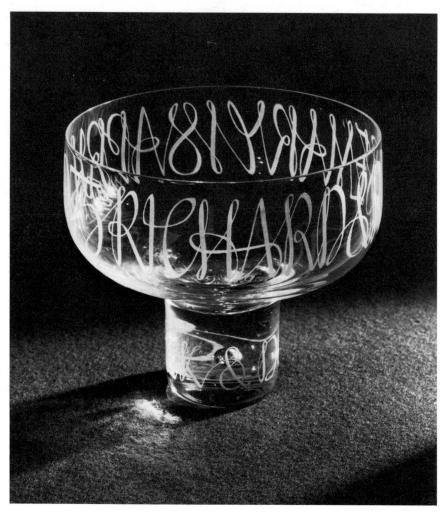

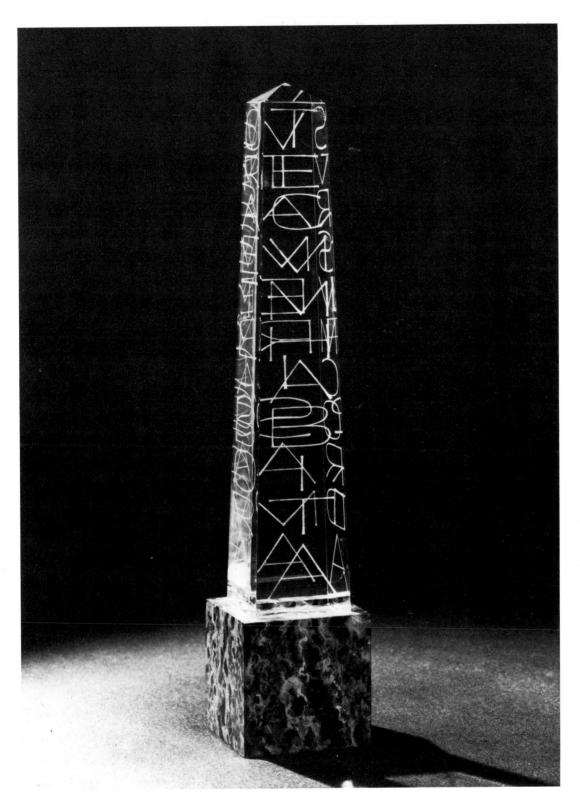

David Peace

Glass obelisk engraved with four Latin mottoes each of 11 letters ending in 'A': Ora et Labora; Sursum Corda; Tecum Habita; Ut Ameris Ama. Overall height including marble base 30.4 cm (12 in).

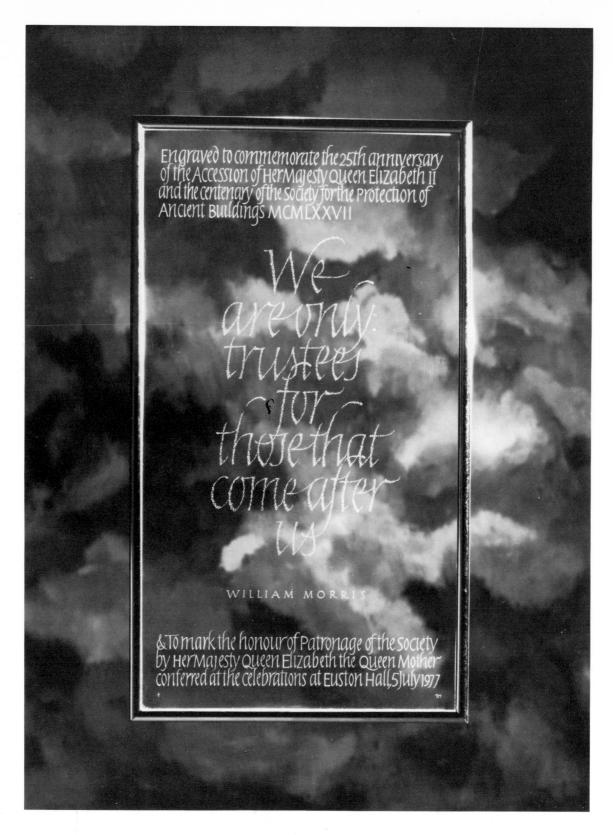

David Peace

Window pane engraved for the committee room of the Society for the protection of Ancient Buildings.

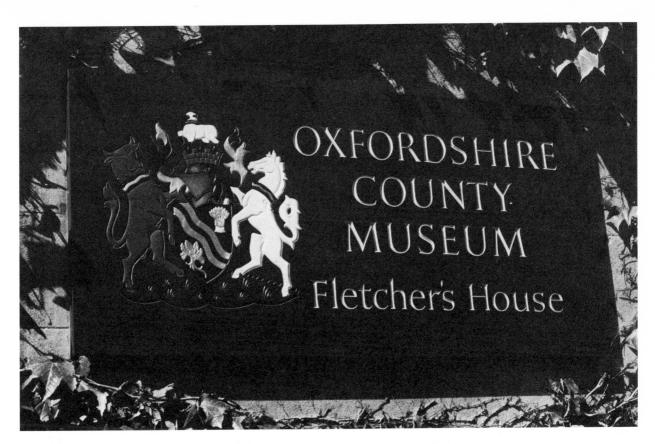

The Bernard Shaw Shop is named to mark the bequest to the British Museum by George Bernard Shaw Dramatist Critic & Author

David Dewey

Name plaque for Oxford County Museum. Slate. 61×126 cm $(23\frac{3}{4} \times 49 \text{ in})$.

John Skelton

Plaque. Welsh slate. Diameter 50.8 cm (20 in).

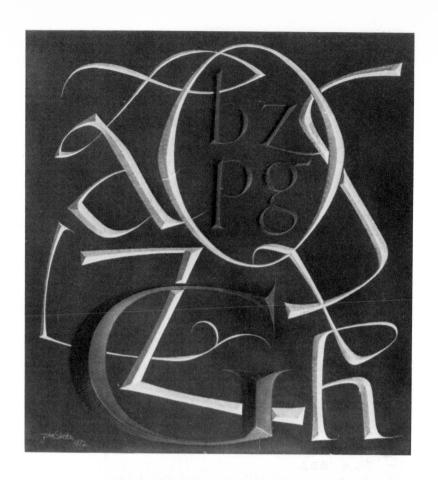

John Skelton

Lettering sample. Slate. 22.8 cm sq (3 ft 6 in).

David Dewey

Slate sign incised and coloured. 69.8 \times 61 cm ($27\frac{1}{2}$ \times 24 in).

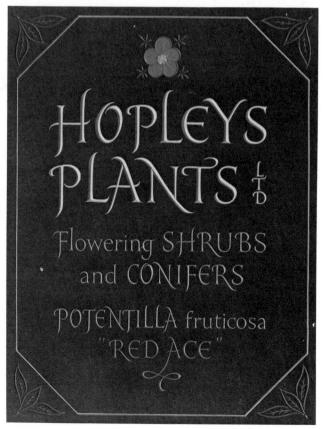

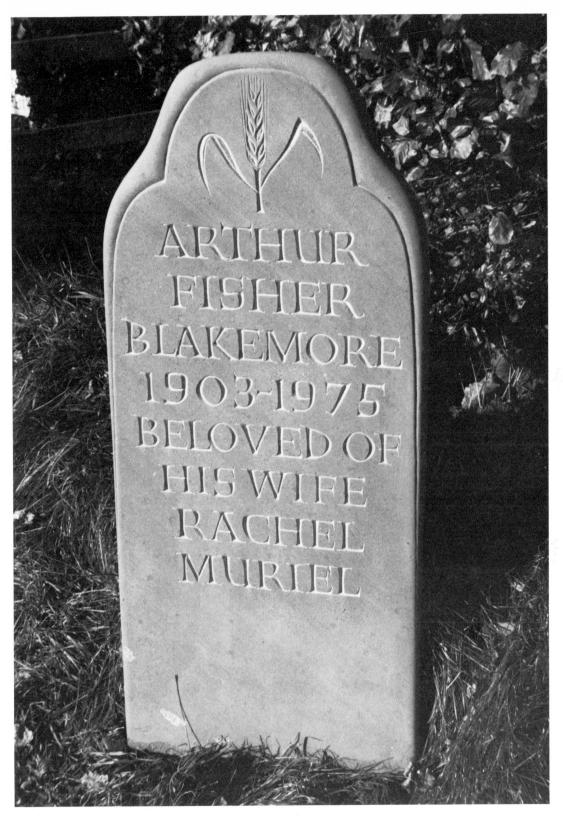

John Skelton Headstone. Red sandstone. Height 1.6 m (3 ft 6 in).

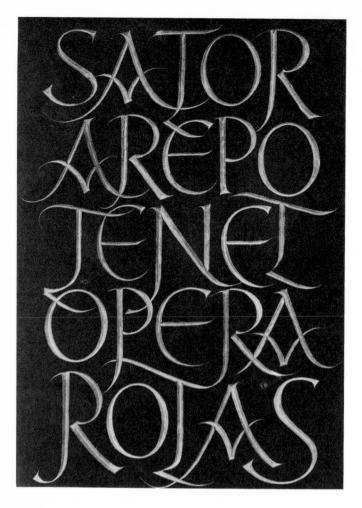

Harry Meadows

Latin inscription cut in slate. 51×30.5 cm (20 \times 12 in).

Thomas Perkins

Latin inscription cut in Yorkstone. Original size 81.2×32.3 cm $(32 \times 12\frac{3}{4} \text{ in})$.

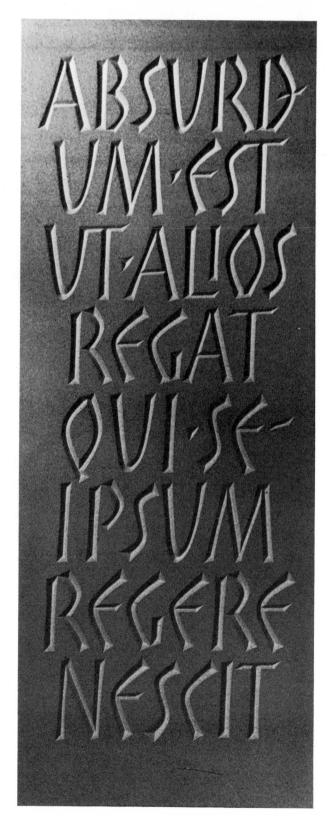

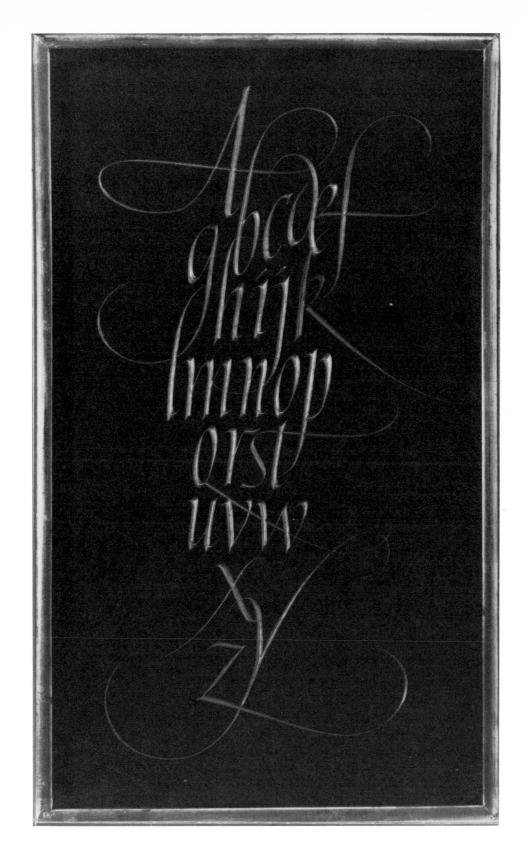

Guillermo Rodriguez-Benitez Italic alphabet cut in slate.

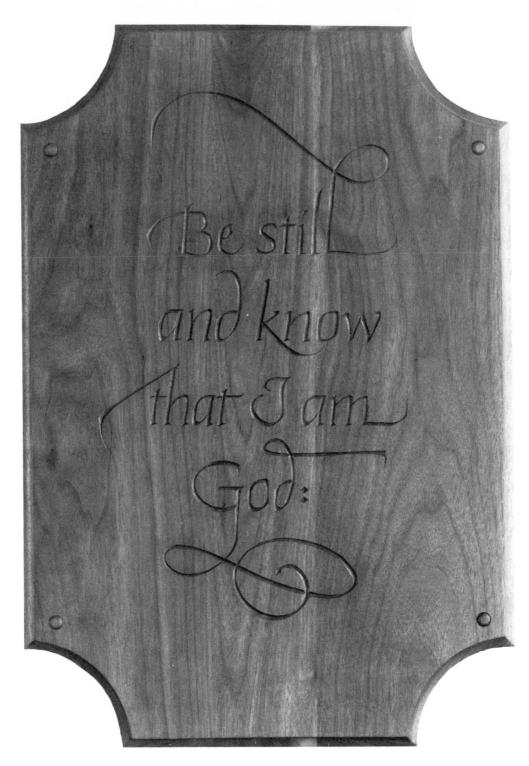

Michael W Hughey Plaque commissioned by a Church. American Walnut. 66 × 47.7 cm (26 × 18 in)

astampa sa in tutto mesentarte la siva mano

John E Benson

Black slate, V-cut gilded letters. 21 \times 28.5 cm ($8\frac{1}{2} \times 11\frac{3}{4}$ in).

John Woodcock

Rings in matching box with engraved lid in silver.

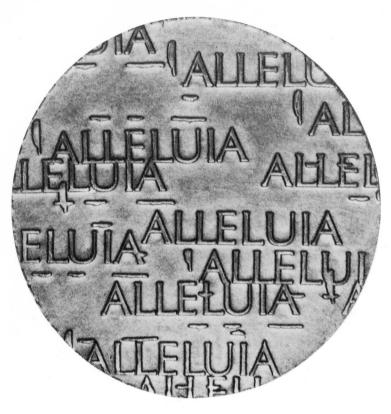

Raymond Gid 'Semaine Sainte'. Medal minted by the Monnaie de Paris. Both sides shown at actual size.

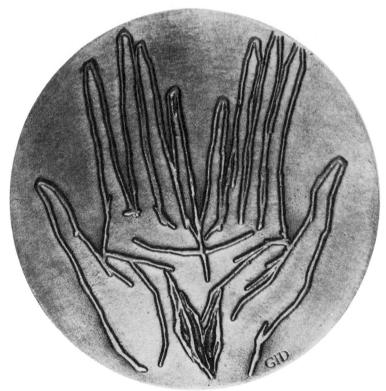

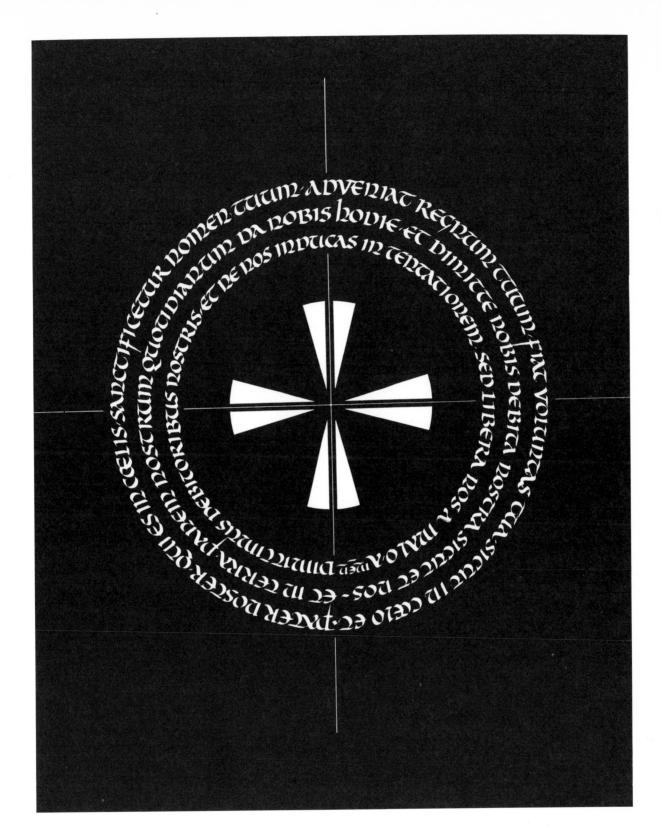

George Thomson

Lord's Prayer. Lettering photo-etched in brass. 25 \times 25 cm ($9\frac{3}{4} \times 9\frac{3}{4}$ in).

Raymond Gid

'À la Calligraphie Renaissante'. To be minted as a medal in 1980. Actual size.

'Célébration de la lettre'. Medal minted by the Monnaie de Paris. Diameter 13.3 cm (5¼ in).

David Kindersley

Plaque engraved with a quotation from Keats' *Lamia*. Mansfield limestone, cut by Lida Lopes Cardozo. 73.6×48.2 cm (29 \times 19 in).

John E Benson Black slate, V-cut gilded letters. 70×41.2 cm $(24 \times 16\frac{1}{4}$ in).

Index of calligraphers

Full addresses of societies or services through which individual artists can be contacted are given on pages 159–160

Alexander, Irene (Canada) 93 Society of Scribes & Illuminators, London

Alice (U.S.A.) 84 Society of Scribes, New York

Angel, Marie (U.K.) 98, 99 Society of Scribes & Illuminators, London

Avery, Dorothy (U.K.) 81 Society of Scribes & Illuminators, London

Baker, Arthur (U.S.A.) 40, 47 Calligraphy Space 2001, New York

Barrie, Stuart (U.K.) 50 Society of Scribes & Illuminators, London

Basu, Hella (U.K.) 31 Society of Scribes & Illuminators, London

Benedict, Anne (U.S.A.) 50 Society of Scribes, New York

Benson, John E (U.S.A.) 74, 151, 156 Calligraphy Space 2001, New York

Berndal, Bo (Sweden) 92, 94 Society of Scribes & Illuminators, London

Boguslav, Raphael (U.S.A.) 18, 21, 23 Calligraphy Space 2001, New York

Boyajian, Robert (U.S.A.) 46 Calligraphy Space 2001, New York

Breese, Kenneth (U.K.) 71, 92, 119 Society of Scribes & Illuminators, London

Christensen, Linda (U.S.A.) 74 The Colleagues of Calligraphy, St Paul, MINN

Clare, Brian P (U.S.A.) 119 Chicago Calligraphy Collective, Chicago

Colleen (U.S.A.) 60 Lettering Arts Guild of Boston

Cooper Barnard, Maura (U.S.A.) 78 Society of Scribes & Illuminators, London

Culmone, Nancy (U.S.A.) 42, 44 Calligraphy Space 2001, New York David, Ismar (U.S.A.) 97, 98 Calligraphy Space 2001, New York

Day, Sydney (U.K.) 105 Society of Scribes & Illuminators, London

Dewey, David (U.K.) 128, 145, 146 Society of Scribes & Illuminators, London

Diamond Chapman, Abigail (U.S.A.) 114, 122 Society of Scribes, New York

Dieterich, Claude (Peru) 17, 48 Society of Scribes & Illuminators, London

Di Spigna, Tony (U.S.A.) 121 Calligraphy Space 2001, New York

Dunham, Ward (U.S.A.) 81, 45 Society of Scribes, New York

Evans, Jean (U.S.A.) 10, 24, 54, 62 Calligraphy Space 2001, New York

Fleuss, Gerry (U.K.) 92 Society of Scribes & Illuminators, London

Freeman, Paul (U.S.A.) 43 Society of Scribes, New York

Gatti, David (U.S.A.) 88 Society of Scribes, New York

Gid, Raymond (France) 152, 154 Society of Scribes & Illuminators, London

Goldberg Marks, Cara (U.S.A.) 59 Society of Scribes, New York

Graham, David (U.K.) 72, 116 Society of Scribes & Illuminators, London

Gray, Nicolete (U.K.) 136 Society of Scribes & Illuminators, London

Gullick, Michael (U.K.) 101 Society of Scribes & Illuminators, London

Halliday, Peter (U.K.) 54, 69, 104, 109 Society of Scribes & Illuminators, London

Hayes, James (U.S.A.) 103 Calligraphy Space 2001, New York Hechle, Ann (U.K.) 30, 62 Society of Scribes & Illuminators, London

Howells, David (U.K.) 117, 126, 130 Society of Scribes & Illuminators, London

Hughey, Michael W (U.S.A.) 150 The Lettering Arts Association, Asheville, NC

Ibbett, Vera (U.K.) 75 Society of Scribes & Illuminators, London

Jackson, Donald (U.K.) 53, 55, 58, 69, 73, 93, 111, 115, 117, 134 Society of Scribes & Illuminators, London

Jackson, Martin (Canada) jacket illustration Society of Scribes & Illuminators, London

Jonsson, Lars (Sweden) 120 Society of Scribes & Illuminators, London

Karl, Anita (U.S.A.) 89 Society of Scribes, New York

Kelly, Jerry (U.S.A.) 14, 48, 51 Calligraphy Space 2001, New York

Kindersley, David (U.K.) 90, 136, 155, 142

Society of Scribes & Illuminators, London

Kindersley, Richard (U.K.) 129, 130, 131, 133, 137

Society of Scribes & Illuminators, London

Knight, Stanley (U.K.) 10, 13, 22, 59 Society of Scribes & Illuminators, London

Larcher, Jean (France) 98 Society of Scribes & Illuminators, London

Linz, Alfred (Germany) 20, 23, 28 Society of Scribes & Illuminators, London

Lopes Cardozo, Lida (U.K.) 92, 138 Society of Scribes & Illuminators, London

Maurer, Paul (U.S.A.) 26, 27 Calligraphy Space 2001, New York

McFarland, James W. (U.S.A.) 24 Society of Scribes, New York Meadows, Harry (U.K.) 148 Society of Scribes & Illuminators, London

Mediavilla, Claude (France) 20, 107, 121 Society of Scribes & Illuminators, London

Mekelburg, David (U.S.A.) 49, 52, 85, 89, 108 Society for Calligraphers, Los Angeles

Metzig, William (U.S.A.) 15, 76 Calligraphy Space 2001, New York

Morris, I (U.K.) 32 Society of Scribes & Illuminators, London

Nasser, Muriel (U.S.A.) 93 Society of Scribes, New York

Neugebauer, Friederich (Germany) 95 Society of Scribes & Illuminators, London

Peace, David (U.K.) 142, 143, 144 Society of Scribes & Illuminators, London

Pearce, Charles (U.K.) 11, 19, 35, 69, 116 Calligraphy Space 2001, New York

Perkins, Thomas (U.K.) 148 Society of Scribes & Illuminators, London

Pilsbury, Joan (U.K.) 38, 75 Society of Scribes & Illuminators, London

Prestianni, John (U.S.A.) 36, 37, 96 Friends of Calligraphy, San Francisco

Quay, David (U.K.) 90, 120 Society of Scribes & Illuminators, London

Quinault Kossakowski, Mary (U.S.A.) 123 Society of Scribes, New York

Raisbeck, Margery (U.K.) 80 Society of Scribes & Illuminators, London

Rees, Ieuan (U.K.) 25, 26, 31, 33, 34, 97, 103, 104, 106, 134, 135 Society of Scribes & Illuminators, London

Richard, St Clair (U.S.A.) 71 Calligraphy Space 2001, New York Robinson, Marcy (U.S.A.) 16 Society of Scribes, New York

Rodriguez-Benitez, Guillermo (U.S.A.) 20, 77, 149 Calligraphy Space 2001, New York

Saltz, Ina (U.S.A.) 73 Society of Scribes, New York

Sakwa, Jaqueline (U.S.A.) 110 Calligraphy Space 2001, New York

Schneider, Werner (Germany) 39, 79 Society of Scribes & Illuminators, London

Shaw, Paul (U.S.A.) 74 Society of Scribes, New York

Skelton, John (U.K.) 132, 145, 146, 147 Society of Scribes & Illuminators, London

Smith, John (U.K.) 96, 107 Society of Scribes & Illuminators, London

Thomson, George (U.K.) 83, 153 Society of Scribes & Illuminators, London

Toots, Villu (Estonia) 12, 24, 61, 100, 118 Society of Scribes & Illuminators, London

Topping, Pat (U.S.A.) 88 Society for Calligraphers, Los Angeles

Urwick, Alison (U.K.) 56, 64 Society of Scribes & Illuminators, London

Veljovic, Jovica (Yugoslavia) 14, 17, 29, 60, 63 Society of Scribes & Illuminators, London

Waters, Sheila (U.K.) 65, 66, 67 Society of Scribes & Illuminators, London

Waters, Julian (U.S.A.) 113, 114 Washington Calligraphers Guild, Washington, DC

Weber, John (U.S.A.) 82, 94 Society of Scribes, New York

Weisberg, Patricia (U.S.A.) 25, 35 Calligraphy Space 2001, New York

Calligraphy societies

Westover, Wendy (U.K.) 16, 82 Society of Scribes & Illuminators, London

Williams, David (U.K.) 30, 64 Society of Scribes & Illuminators, London

Winkworth, Bryan (U.K.) 36 Society of Scribes & Illuminators, London

Winters, Nancy (U.K.) 91, 102 Society of Scribes & Illuminators, London

Wong, Jeanyee (U.S.A.) 27, 32 Calligraphy Space 2001, New York

Woodcock, John (U.K.) 42, 151 Society of Scribes & Illuminators, London

Zapf, Hermann (Germany) 38, 86 Society of Scribes & Illuminators, London Calligraphy societies in USA and Canada

Calligraphers Guild P.O. Box 304, Ashland, OR 97520

Calligraphy Guild of Pittsburgh P.O. Box 8167, Pittsburgh, PA 15217

Capital Calligraphers 332 Atwater S, Monmouth, OR 97361

Chicago Calligraphy Collective P.O. Box 11333, Chicago, ILL 60611

Colleagues of Calligraphy P.O. Box 4024, St. Paul, MINN 55104

Colorado Calligraphers Guild Cherry Creek Station, Box 6413, COLO 80206

Escribiente P.O. Box 26718, Albuquerque, NM 87125

The Fairbank Society 4578 Hughes Road, RR3 Victoria, B.C., Canada V8X 3X1

Friends of Calligraphy P.O. Box 5194, San Francisco, CA 94101

Friends of the Alphabet P.O. Box 11764, Atlanta, Georgia 30355

Goose Quill Guild Oregon State University, Fairbanks Hall, Corvallis, OR 97331

Guild of Bookworkers 663 Fifth Avenue, New York City, NY 10022

Handwriters Guild of Toronto 60 Logandale Road, Willowdale, Ontario, Canada M2N 4H4

Houston Calligraphy Guild c/o 1024 Willow Oaks, Pasadena, TX 77506

Indiana Calligraphers Association 2501 Pamela Drive, New Albany, IND 47150 Island Scribes c/o 1000 E 98th Street, Brooklyn, NY 11236

The League of Handbinders 7513 Melrose Avenue, Los Angeles, CA 90046

Lettering Arts Association 303 Cumberland Avenue, Asheville, NC 28801

Lettering Arts Guild of Boston 86 Rockview Street, Jamaica Plain, MA 02130

New Orleans Calligraphers Association 6161 Marquette Place, New Orleans, LA 70118

Opulent Order of Practising Scribes 1310 West Seventh, Roswell, NM 88201

Philadelphia Calligraphers Society P.B. Box 7174, Elkins Park, PA 19117

Phoenix Society for Calligraphy 1709 North 7th Street, Phoenix, AR 85006

San Antonio Calligraphers Guild c/o 3118 Mindoro, San Antonio, TX 78217

St. Louis Calligraphy Guild 8541 Douglas Court, Brentwood, MO 63144

St. Petersburg Society of Scribes c/o 2960 58th Avenue S, St. Petersburg, FLA 33712

Society for Calligraphy & Handwriting c/o The Factory of Visual Art, 4649 Sunnyside North, Seattle, WA 98103

Society for Calligraphy P.O. Box 64174, Los Angeles, CA 90064

Society for Italic Handwriting, BC Branch P.O. Box 48390, Bentall Centre, Vancouver, B.C., Canada V7X 1A2

Calligraphy services

Society of Scribes P.O. Box 933, New York City, NY 10022

Tidewater Calligraphy Guild 220 Cortland Lane, Virginia Beach, VA 23452

Valley Calligraphy Guild 3241 Kevington, Eugene, OR 97405

Washington Calligraphers Guild Box 23818, Washington, DC 20024

Western American Branch of the S.I.H. 6800 S.E. 32nd Avenue, Portland, OR 97202

The Western Reserve Calligraphers 3279 Warrensville Center Road, Shaker Heights, Ohio 44122

Wisconsin Calligraphers' Guild 2124 Kendall Avenue, Madison, WI 53705

Calligraphy societies in Europe

The Society of Scribes & Illuminators c/o FBCS, 43 Earlham Street, London WC2H 9LD

The Society for Italic Handwriting 69 Arlington Road, London NW I

The Mercator Society Gaasterland Str 96, Haarlem, Holland Bund Deutscher Buchkunstler 6050 Offenbach am Main, Hernstrasse 81, W. Germany Calligraphia 5060 Bellaire Avenue, N. Hollywood, CA 91607

Calligraphics Ink, Inc. Crystal Underground, Arlington, VA 22202 USA

Calligraphy Design Center 1720 E 86th Street, Indianapolis, IND 46240

Calligraphy Space 2001 644 Broadway, New York City, NY 10012

Scriptorium St. Francis 1323 Cole Street, San Francisco, CA 94117